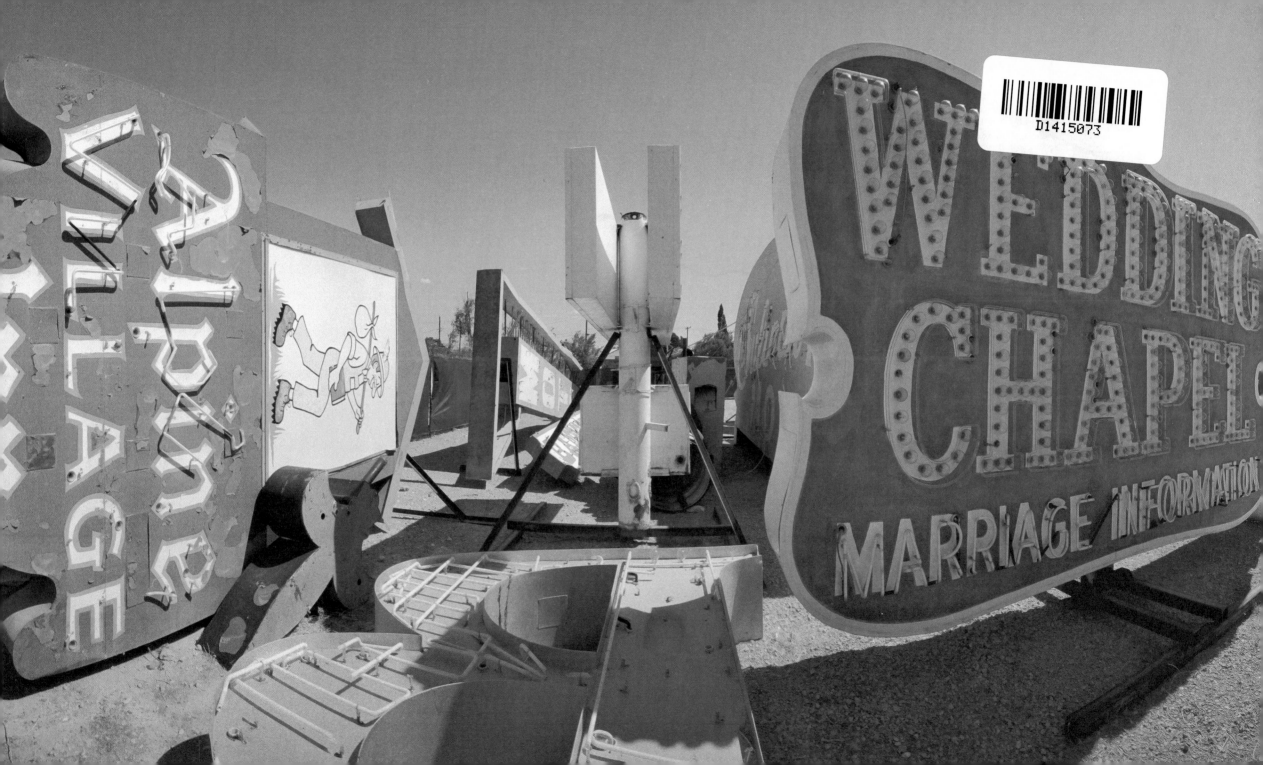

Vegas 360°

Vegas 360°

Panoramic Photographs of Las Vegas by Thomas R. Schiff

BRIGHT CITY BOOKS

ISBN 978-0-9795898-1-2

Photographer: Thomas R. Schiff
Editor: Eric Olsen
Digital Image Manager: Jacob Drabik
Digital Image Assistant: Ryan Elliott
Design: Robin Terra, Terra Studio, San Francisco, CA

Cover image: *New York New York, Entryway*, 2006

Endpapers: *Neon Museum, Boneyard*, 2006.
Photographed with permission of The Neon Museum, Las Vegas, Nevada.
Fontainebleau Resort, Construction Site, 2007

All photographs illustrated exist as digital files and are produced by the
artist as glossy prints on photographic papers of varying kinds, in varying
dimensions, and in editions of varying sizes unless otherwise indicated.

Proceeds from the sale of this book benefit Las Vegas Art Museum,
Las Vegas, Nevada.

Printed in China.

FSC

Mixed Sources
Product group from well-managed
forests, and other controlled sources
www.fsc.org Cert no. SGS-COC-003563
© 1996 Forest Stewardship Council

BRIGHTCITY**BOOKS**
Las Vegas Los Angeles Miami Beach
www.brightcitybooks.com

Contents

Panoramarino Dave Hickey

Thomas Schiff's panoramic photographs of Las Vegas are a gift to us all: to gamblers, hookers, art lovers, moguls, designers, architects, rubberneckers, looky-loos, and everyone else. Schiff's panoramas provide us with the ultimate medium through which we may see what Las Vegas really looks like—and get an inkling of why it really works. Schiff's process might well have been designed to capture the great, visual eccentricity of the Strip—its ambient, floating dazzle of light in space that always eludes ordinary film and photography. The panoramas' broad sweep solves what photographers call the "color/space" prob-lem—the fact that intense color obliterates photographic space, while self-consciously evocative space tends to suppress the intensity of color. Schiff's panoramas retain the color and the space.

Schiff's medium also exploits the "Buckaroo Banzai" principle so well-known in Vegas—the axiom that "wherever you go, there you are"—right in the middle of everything, where everything is designed to de-fuse your focus on anything in particular, and your camera's focus, too. That's the trick: In Vegas, there is nothing to look at and everything to see! This is why Vegas is so comfortable for art critics. The city celebrates the attraction of distraction, the mystery of what's behind you or right over there. We rove through the lights, the noise, the bells and whistles—the walls disguised with flowers, trees, murals, metal, green-glass castles, boîtes, bistros, mirrors, waterfalls, and Palladian porticos. We wander across fields of carpet that spread away forever, Aubusson, Oriental, Danish, Turkish, Googie, and everything else. We are nearly always lost and that's the fun of it. The fun of Schiff's photographs is that they allow us to orient ourselves just a little. But not too much.

The tourist bureau will tell you that what happens in Vegas stays in Vegas; they don't tell you that the things that happen in Vegas almost never happen right before your eyes. They sparkle in the rapture of the atmosphere. Elevator doors, I must admit, do, occasionally, open onto amazing scenes of sex and disha-bille, but generally, unless we ourselves are performing in the elevator, we just catch a glimpse, out of the corner of our eye, of the Asian gentleman at the baccarat table raising his wrist to his forehead. We note the giant cheer that goes up around the craps table somewhere off to the right. A commensurate moan arises behind us at the roulette wheel. A cowboy shouts "Whoopee" as the river card in a hand of Hold

'Em flips out. Somewhere out there in the glittering field of slot machines, bells are ringing and we hear a lady screaming at her row of four Red Sevens, *Oh my God! Oh my God! Oh my God!*—thus demonstrating the roots of religion. Off in the distance, a wedding party in white lace and tuxedos passes in procession into an ersatz jungle. Right in front of them, Charles Barkley with his cigar at an upward tilt, surveys the blackjack table, and way over there, my God, it's George Clooney glittering in his own charisma.

These things happen in Vegas. They have been happening in Vegas for a long time. It has taken thirty years, however, to design the ideal places for these things to happen glamorously and gloriously. This reconception began with Morris Lapidus' idea that commercial architecture is always, in some sense, a souk. In Vegas, it is a souk where one shops for sin, false self-esteem, and excess, but the primitive design still applies: Four sticks stuck in the sand supporting a rectangular cloth that blocks the sun. Beneath the tent, there is a carpet upon which the merchant's wares are displayed. There is a shade to shield the busi-ness from the sun and the sight of God; there is a carpet to shield the business from the entropy of nature. Between cloth and carpet, the space of commerce spreads around the world. Surrounding each site there are other tents, carpets, and goods for sale in the porous confluence of pandemonium and negotiation. Multiply that Arabian souk a million times and you will have the Las Vegas Strip: All floors, all ceilings, but no walls—or, rather, no walls that aren't disguised as other stuff. Commerce knows no boundaries. The diversity and extravagance of the Strip arises from the simple fact that all the businesses on the Strip do the *same business*: gambling, innkeeping, dining, shopping, dancing, and entertainment. Diversity arises for its own sake, distinguishing nothing but the relative panache of each sales pitch.

The intellectual delight of Schiff's panoramas arises from this penchant for distinction for its own sake. The Strip is a giant charette, in Schiff's vision of it, with thousands upon thousands of solutions to ex-actly the same problems, on exactly the same kind of sites, by exactly the same logic of exuberant com-mercial necessity. Most critically, Schiff's pictures reveal the 360-degree design logic that is otherwise available to none but dizzy drunks and dervishes. It's good to know what's behind you. That's a given, but it was not always like this on the Strip. In the old days, a beige wall with an Exit sign was probably behind

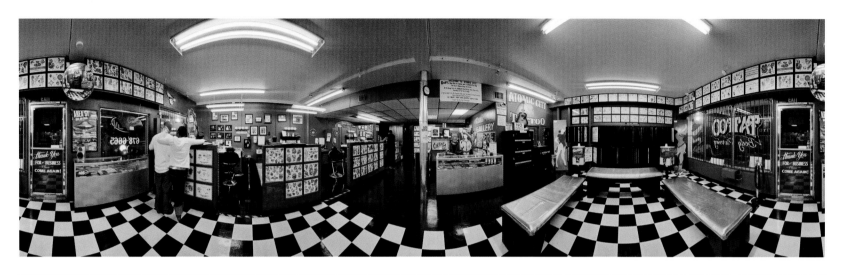

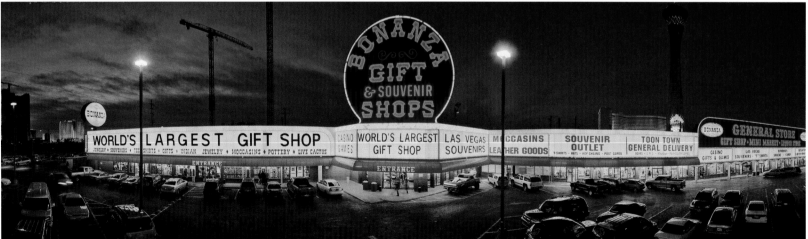

Top, Atomic City Tattoo, 2006; below, World's Largest Gift Shop, 2006

you. Then a visionary mogul, Moe Dalitz, I think, announced that he never wanted to see another beige wall with an Exit sign and a pay phone. Now you don't.

As Robert Venturi famously demonstrated in his book *Learning from Las Vegas*, the Strip in its vernacular configuration was little more than a long mall of big boxes with steaming parking lots and wonderful signs. Venturi called these buildings "decorated sheds." Gradually the "sheds" became the signs. Venturi called these buildings "ducks," after an LA restaurant shaped like a duck. A "duck" is a building designed to look like something else.

Caesars Palace was the first great vernacular duck, from which all the rest derive. Every accidentally successful design element dreamed up and improvised at Caesars has since been rationalized and applied everywhere—thus the subliminal echoes that ring through most of the new post-Caesars casinos in which the same principles have been applied, in more refined configurations.

Caesars itself was the first exotically themed casino, designed to mimic Roman Splendor (and, covertly, of course, to proclaim the Italian heritage of La Cosa Nostra). The problem with the duck, however, is that it depends on facades and prosceniums that divide actors from participants, like fake western towns. Then Steve Wynn realized that casinos were best built from the inside out to exploit what Venturi called the "arboreal coziness" of their long, low spaces that are at once public and private. Inside, after all, is where the money is made. So gradually the "theatrical ducks" were transformed into "theatrical agoras"—sheltered piazzas with outrageous amenities. At this point Vegas did for architecture what easel painting did for painting. The panel or stretcher bar made painting mobile. Theatrical appropriation in Las Vegas made architecture mobile. Venice arrived in Vegas along with the Caribbean, Paris, Egypt, Lake Como, and the South Seas.

This was the first step toward making Schiff's panoramas the optimum way of looking at Vegas. There are other reasons. First, Vegas had never had a summer season because summer is hot as hell. Even so, thousands of German tourists and vacationing rednecks, families in tow, drove through Vegas every summer on their way from the Grand Canyon to Disneyland. Some very shrewd dudes built "family friendly" casinos for these transient Winnobagoneers to rest and refresh themselves. And suddenly Vegas had a summer season, and public space problems, and heat problems. These optimized the necessity of valet parking, vaulted outdoor spaces, a shade for Fremont Street, and giant indoor spaces that seemed to be outdoor spaces with painted skies. Thus the inside became outside and vice versa; 360-degree design became the norm and the panoramic photograph became the only way to see what Vegas really is.

Other attributes arose out of necessity. The spate of Vegas movies, TV serials, and on-line poker created a feedback loop that intensified the volume of customers. This required bigger buildings, which would be overwhelming and intimidating if they looked as big as they actually are. So casinos started hiding their windows to disguise the scale of the buildings, or multiplying the facades, as they did at New York New York. Suddenly, inevitably, the Strip ceased to be Venturi's motor freeway and became a pedestrian paradise. This required bringing buildings and amenities out closer to the street for shade and easy access. Attractions, like the Volcano at the Mirage, the Pirate Battle at Treasure Island, and the fountains at Bellagio—all Steve Wynn's inventions and none drive-by friendly—were created to lure pedestrians. That was the last phase. Today, just as the ducks replaced the decorated sheds, haut-design, high-art, and big-name architects are replacing themed ducks. So now, in a dense space approximately the size of midtown Manhattan, there exists a confluence of more color, visual eccentricity, brilliant innovation, stunning piazzas, high-end shopping, high-stakes wagering, world-class distraction, flagrant illumination, and exotic architecture than the entire nation of the United States could boast in 1960. If you doubt me, have a look at Schiff's panoramas.

Photographer's Note Thomas R. Schiff

Consider the eyes of a predator, the eyes of a tiger or hawk, say, or for that matter of a human. They are set in the front of the face, perfectly situated for stalking. Good ol' binocular vision; there's nothing like it for judging the leap onto the back of a gazelle, the toss of a spear. The predator's field of vision is narrow, but what need does the predator have for a wide field of vision? He's not worried about what might be sneaking up on him. Who would dare? The hunted, however, needs those bulging, nervous, liquid brown eyes positioned on the sides of the face, always swiveling, twitching, always on the lookout for danger from all angles at all times.

I bring this up—these two disparate visual systems—by way of trying to explain my fascination with panoramic photography. I run an insurance agency, and through grim experience, like all my colleagues in the business, I've developed the sensibilities of the hunted. One spends one's days in the insurance game always on the lookout for trouble, which can come from any angle at any time in a maddening variety of forms: as fire or windstorm, as an automobile accident—some minor, some catastrophic—the grim results of human folly or dumb chance or… I could go on and on, but my point is that the panoramic format is perfectly suited to someone who has learned to be on the lookout, always: that wide field of vision, that expansive, all-encompassing miss-nothing view.

In the fourth grade, I was given a Kodak Brownie. I took it to school and took photos of my friends and loved it. I've been at it ever since. After the Brownie, I graduated to more sophisticated cameras, and my love for the art and technology grew. I was self-taught early on. I learned by asking questions at the local camera shops and looking at photos in books and magazines, trying to figure out what makes one photograph better than another. I was a photographer for the school newspaper, of course, and of course I took photographs for the yearbook.

My first cameras were nothing fancy. Composing a shot with one of these cameras with its constrained field of view was a process of distilling information to the essence, of cropping, taking away, and focusing in. The process was like a hunter's way of framing his world: a sharp focus on a future meal for the one, a sharp focus on a beautiful photograph for the other, for both the exclusion of everything beyond that narrow field of vision.

At Ohio University, I pursued a business degree while studying photography under two fine photographers, Clarence White, Jr., and Arnold Gasson. I learned about composition and tonal values. I learned how a photo can tell a story. I flirted with the idea of going into photography full-time, but finally opted to enter the family's insurance business. On the side, I continued with my photography. At first, I worked only in black and white, in part because I found the technology of the color process tedious and somewhat dicey. Besides, color was too realistic. I preferred the abstraction of black and white that allowed one to distill the image to its essence.

Then, in 1994, I discovered panoramic photography. It was a revelation. A little light flicked on in my mind. Of course. By then I'd been in the insurance business for years, for years on the lookout for risk and disaster, beleaguered on all sides by the workings of bad luck, human error, and cupidity. I was, to be blunt, more than temperamentally and artistically ready for a technology that allowed me to "see" all around me, 360 degrees. I also felt that I had begun to repeat myself, and the panoramic technology opened up new opportunities for expression.

My first panoramic camera was an 8-by-10 view camera with a panoramic back. It was big and bulky and finicky, but I liked the huge negatives and used that camera for years. Then I discovered the camera I used to take all the photographs in this book, the Hulcherama 360 Panoramic Camera. The Hulcherama was designed by Charles Hulcher, an engineer who'd also designed a number of high-speed custom cameras for NASA.

Along the way, I began to do more color. The distortion and unnatural viewing angle of the panoramic view allowed me to work in color and still retain the abstract qualities I enjoyed with black and white. Also, I suspect that the new, all-inclusive view of the world made possible by the panoramic camera required the

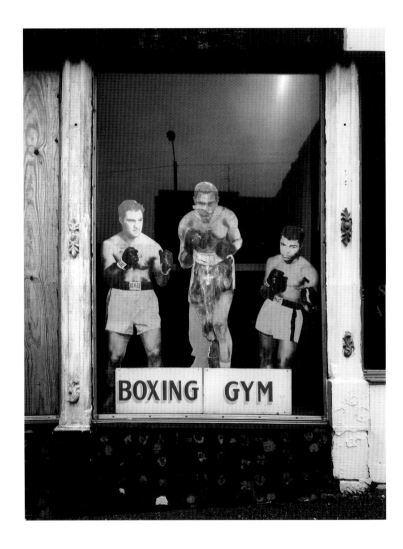

Boxing Gym, Mansfield, Ohio, 1978; gelatin-silver print; 13½" x 10½"

inclusion of color. If you're taking it all in, after all, why not take it all in in full color? Certainly Las Vegas demanded full color... and then some.

All of the photos in this book were taken on Fuji or Kodak 220 roll film, the images then digitized. I prefer to work with film for a variety of reasons, not least because I think film provides a higher quality and more expressive range of colors than even the best digital systems. Also, the technology of panoramic photography has lagged behind other types of photography in the turn to digitization. Even so, panoramic photography gives one the luxury of a liberating, all-inclusive field of view, and this liberation also presents certain challenges and—like liberation of any kind—some constraints. Because the camera is in operation for several seconds as it spins through a single exposure, any movement in the field of view becomes blurred. Sometimes that's the effect you want; sometimes not. For that same reason, the long exposure, a flash is out of the question; you must rely on ambient light. Of course, Las Vegas has plenty of that.

Also, the standard camera with its narrow field of view allows one to crop out the unwanted and unnecessary. But the panoramic format means you have to keep it all in, the good, the bad, and the ugly. Thus the panoramic photographer spends a good deal of time searching for the ideal setting, the perfect shot, standing in one spot doing a slow spin, perhaps several slow spins, taking it all in, on the lookout for that visual squeak that might ruin the shot. One "composes" the shot before ever setting up the camera.

I find this part of the process particularly appealing, and it gets back to my original point about the visual "thinking" of predators and prey. You'll see two broad types of photographs in this collection: those with a "center" and those without. The "uncentered" shots tend to "read" more panoramic than the "centered" shots, though both take in a full 360 degrees, or more. An uncentered shot begins with the camera aimed at what will be the edge of the finished shot, often at something that might "anchor" the edge. But the centered shot begins with the camera aimed directly *away* from the intended center. One sneaks up on such a shot. I rather like the hint of trickiness involved, that glance away, the magician's diversion. Dare I say it? At such a moment, I think the hunted can think like the hunter.

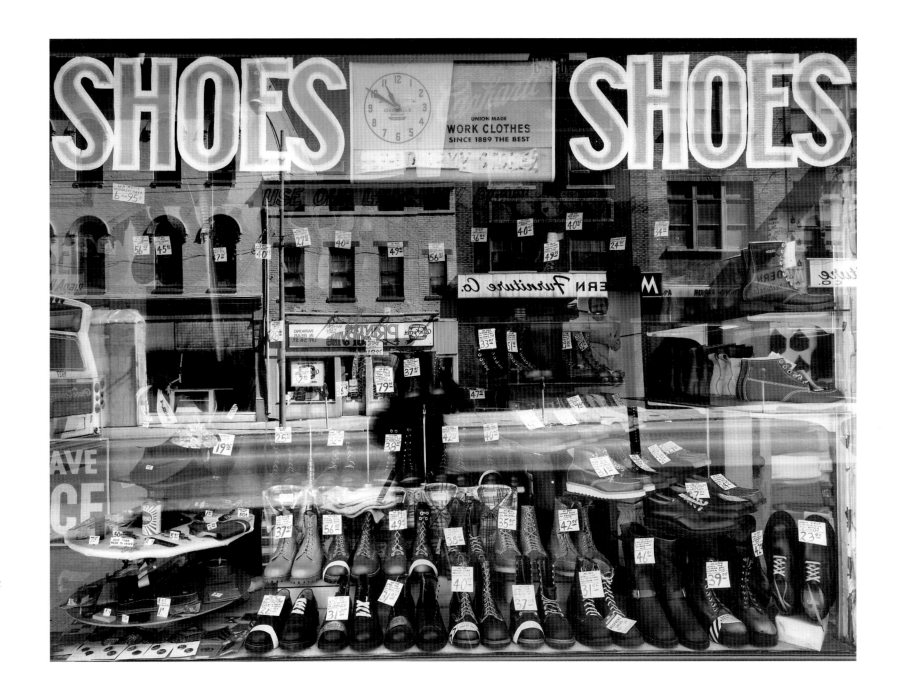

Shoes, Shoes, 1982;
gelatin-silver print;
10½" x 13½"

Plates

All of the photographs in *Vegas 360°* were
taken with a Hulcherama 360 camera using
220 film. The camera is mounted on an
extended tripod and rotates 360 degrees
or more on its axis, exposing film in a
continuous strip as it turns.

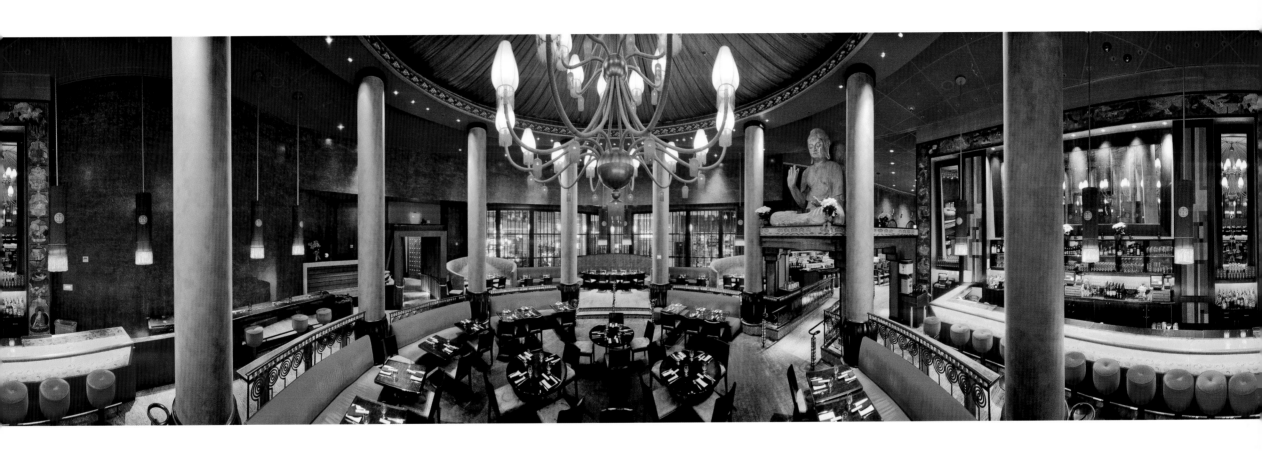

Little Buddha Restaurant, 2006

Madame Tussauds, 2006

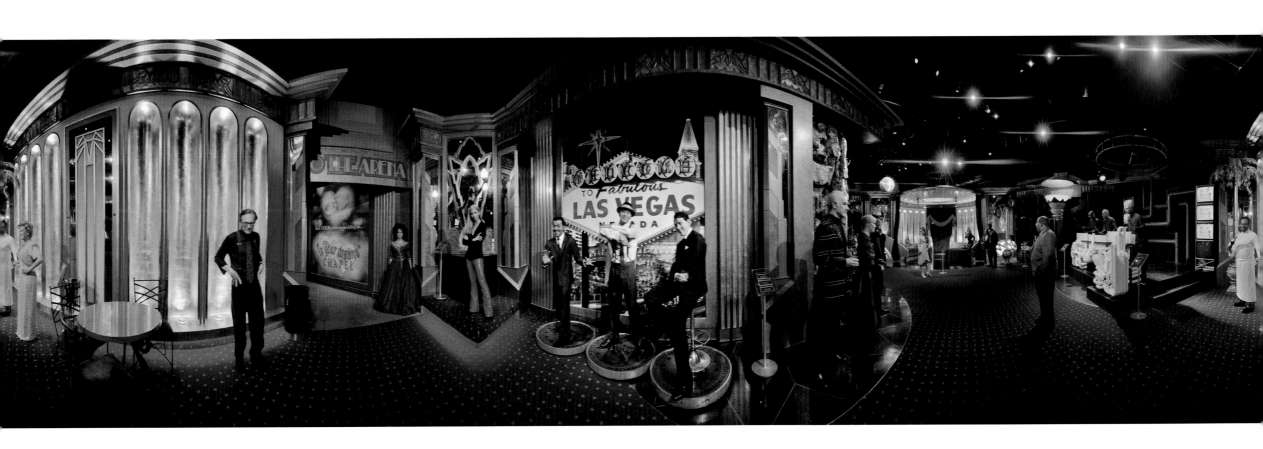

Tabu Ultra Lounge, 2006

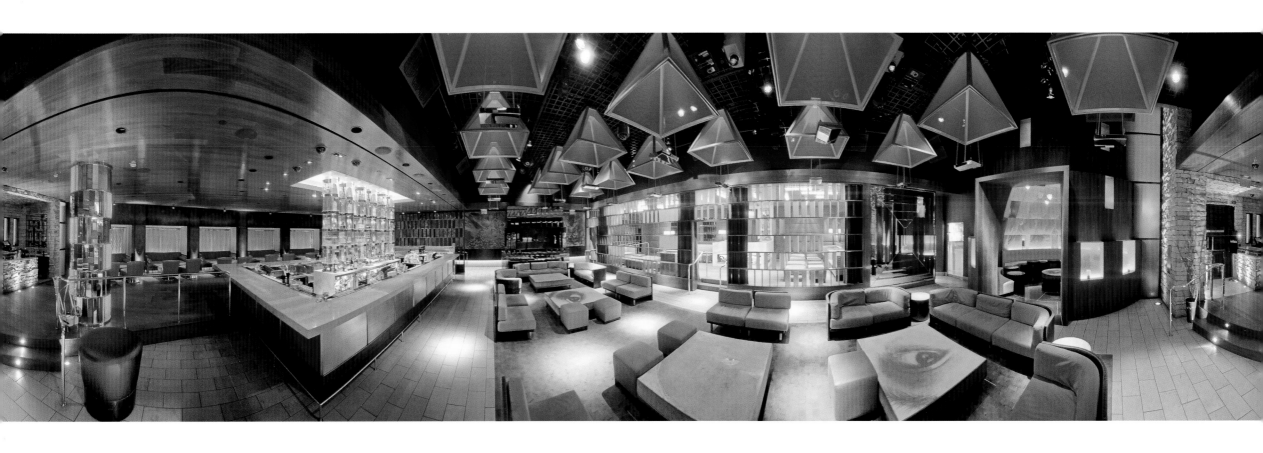

Peppermill's Fireside Lounge, 2006

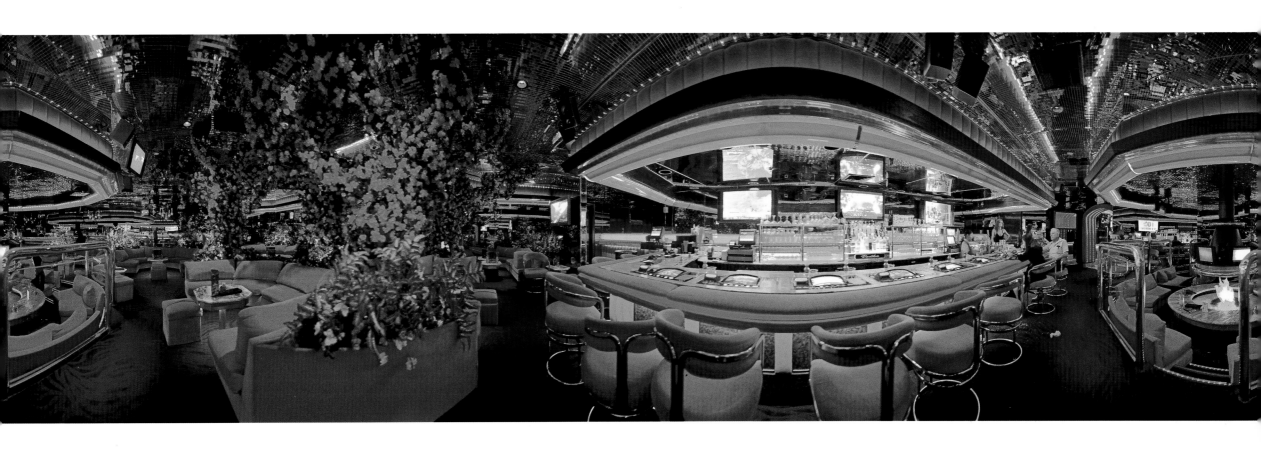

Elemental Vegas David Surratt

Most commentaries on Las Vegas sooner or later get to matters of overconsumption and moral bankruptcy, sure, but these tend to miss something about this city that's just as legitimate and much harder to describe. Whatever it is, it can turn up anywhere, usually without much warning.

One night it descends on the Strip's old Aladdin Theater during the opening night performance of *Stomp Out Loud*, an orgy of resourceful percussion had by mute rascals in blue-collar regalia who coax beats from barrels, hubcaps, push brooms, car keys, and everything else under a ceiling of 5000-watt suns. They make a clever, complex noise, practiced and perfect—exactly the show expected by a room full of tourists who've come for the forget-bosses-and-bills oblivion their travel guides promised. The audience thrills. Not just at the unlikely drums or the performers or the slapstick, but at the actual slapping of unlikely drums and performers with sticks. The *Stomp* crew isn't done, though. Just when it seems they've cashed in, the five-gallon water bottles come out—numerous empty jugs they toss two-handed to each other in a serpentine, looping ballet of pitch and catch remarkable not just for the syncopated beats themselves, but for the even more kinetic rests in between, so easily visualized in arcs of thrown plastic.

It shows up again one day at dusk, miles from the Strip, during a community theater performance of Bob Carlton's 1989 sci-fi-meets-Shakespeare musical *Return to the Forbidden Planet* held at Spring Mountain Ranch's outdoor amphitheater. At the end of the first act, evil genius Dr. Prospero guzzles a secret formula, then gags and collapses. Alarms blare on the starship's bridge and crew members dance and roller-skate in horror at the enormous green papier-mâché tentacles lunging in from the wings. All this is set to a scroungy, raging rendition of Van Morrison's "Gloria" and the half-ecstatic, half-terrorized yelps of children whose parents laugh on picnic blankets and uncork Shiraz under a sky full of warm wind and swooping bats.

Sunday morning before dawn, it's back on the Strip. The scene at Jet, Mirage's vast ultralounge, is at full-tilt. Clubbers preen, prowl, swirl $13 cocktails and agitate to a thunderous wash of electronica spun by local DJ Farsheed and Dutch-born progressive trance luminary Ferry Corsten. The bass is palpable liver-deep, the melody pretty and obscene. It's impossible to converse. It's better not to try. Faces flash under the LED-paneled ceiling, nearby squeals are inaudible and, by dawn, Jet is a purgatory of leisure.

By noon, a flannelled pensioner playing double bonus poker in a dive on the east side finally hits the royal flush he's been silently praying for from this goddamned machine ever since his first Wild Turkey seven hours ago. He's still down, way down, but a royal's a royal and he knows it. So does the platinum-haired, doe-eyed bartender, who's genuinely happy to drop her rag, come around the bar and dance with him to the chorus of Boston's "Feels Like the First Time."

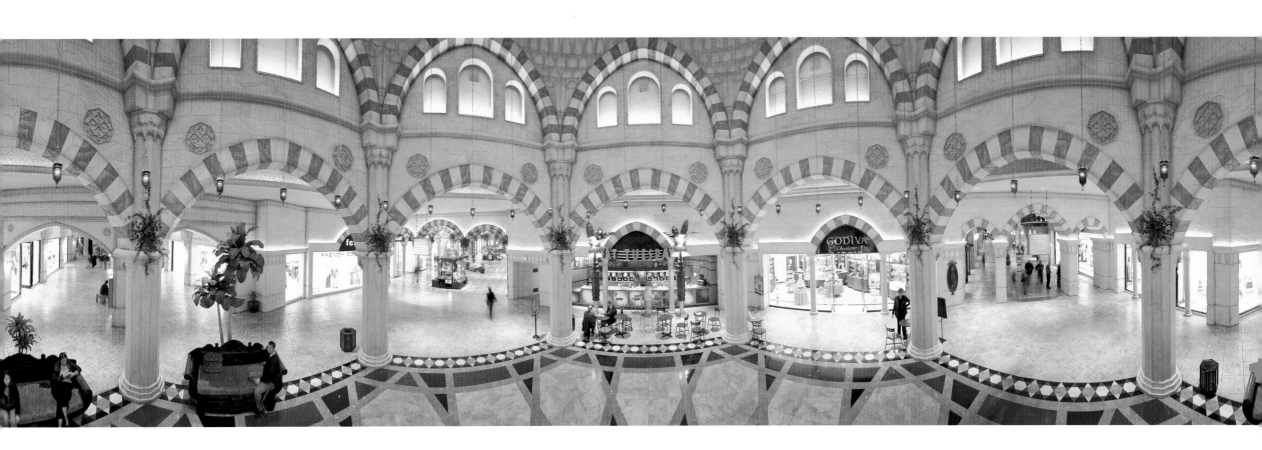

Aladdin Resort and Casino, Courtyard, 2004

Hilton SpaceQuest Casino, 2006

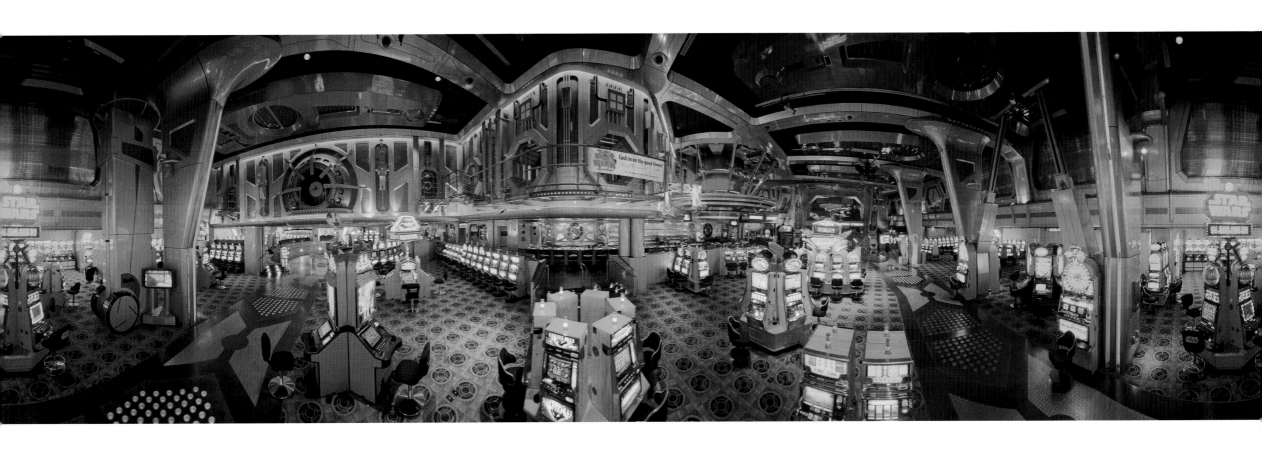

Hilton SpaceQuest Casino, Ramp, 2006

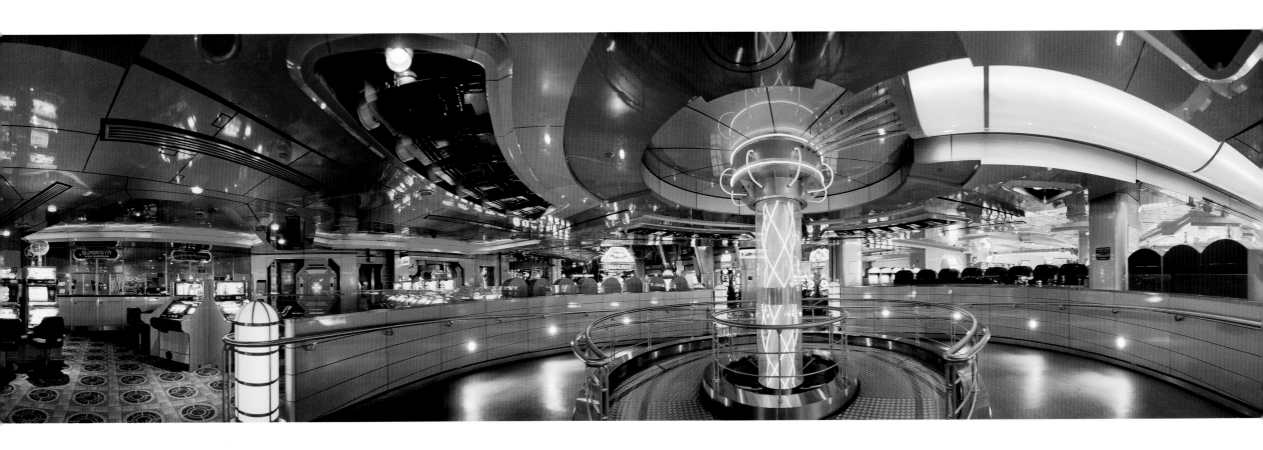

The Hotel, Lobby, 2006

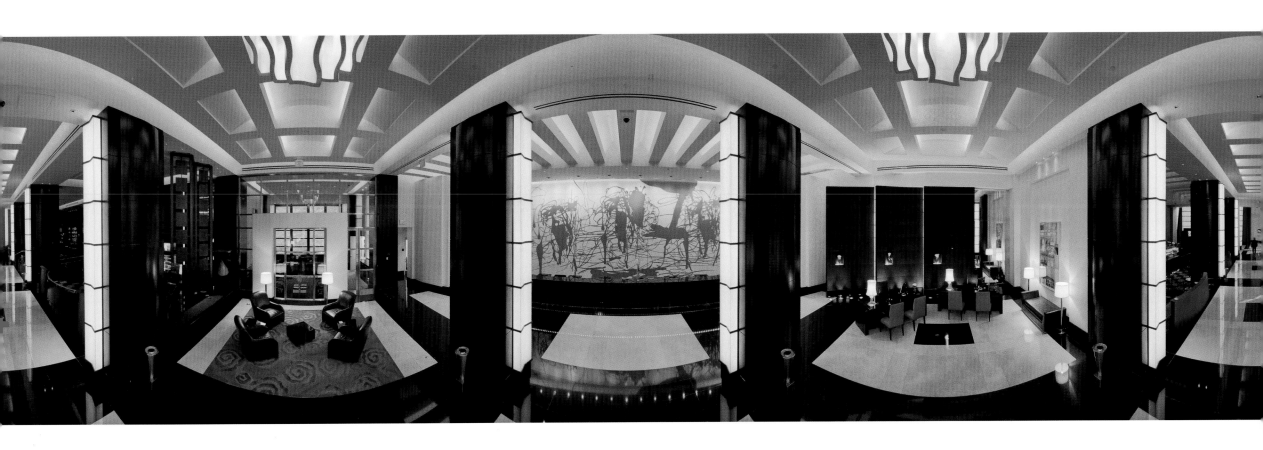

Classic Vegas Visit, and Then Some
A.D. Hopkins

Today's visitor walks in the shade of an expansive metal canopy as wide as the street itself and the length of four football fields, in what is known these days as the Fremont Street Experience. But one day in May 1905, potential residents had to sweat out a three-digit afternoon under straw hats and umbrellas as they bid on lots in the new boomtown promised by the builders of a new railroad, who, by the way, happened to be auctioning off the lots.

The big payoff was long in coming, though, arriving only when Nevada legalized casino gambling in 1931 and the cafes and groceries and dry-goods stores that lined the street quickly became sawdust joints and saloons. For some 50 years thereafter, downtown Las Vegas was on a roll, a run of good luck that didn't give out until development on Las Vegas Boulevard—the Strip—siphoned off that tourist trade and suburban casinos stole the locals.

In the early '90s, the City of Las Vegas closed the street to vehicles, then built a $70 million canopy over it, studded with some 12.5 million LED bulbs programmed to paint pictures moving the length and breadth of the canopy. Fremont Street was reborn in 1994. More or less.

I park in the garage of Binion's Gambling Hall and Hotel, take an elevator to the casino floor, and walk out past the craps tables. The place is clean and busy, but some of the free-for-all ruckus of the old days is gone, when the pretty blackjack dealers smiled suggestively, free drinks came fast and furiously, and you threw money away at the tables and liked it.

The sound of a saxophone draws me through the casino, out onto the street. But instead of the bumper-to-bumper cruisers of mid-century, Fremont is now filled with hucksters and hawkers selling sunglasses and t-shirts. A knot of people surrounds a street musician; he's scruffy-looking but he can flat play that sax.

Some of the "old" Fremont Street does still linger here and there, iconic neon signs from the original Vegas joints, famous but fallen to make way for the new. They glow again—honorably preserved—the disbursed exhibits of The Neon Museum. Here's the rearing rider from the old Hacienda, there a lamp from the Aladdin, and yonder the cocktail glass, complete with cherry, from the old Red Barn. Out under the canopy, the 75-foot tall neon cowboy called Vegas Vic, a Fremont Street fixture since 1951, still welcomes visitors with a friendly wave of his arm.

At 8:30 p.m., the sax player bows and yields his audience to the first of four lightshows scheduled nightly on the canopy above.

The show that romps across it now is an animated short about a pretty girl in a red 1970s minidress, swimming through an underwater world in an exciting dream. At least she finds it exciting.

The elderly couple standing next to me does not find it so. "Is that it?" the woman asks me.

"I think so," I say. And I think, "Whaddaya want for $70 milllion?"

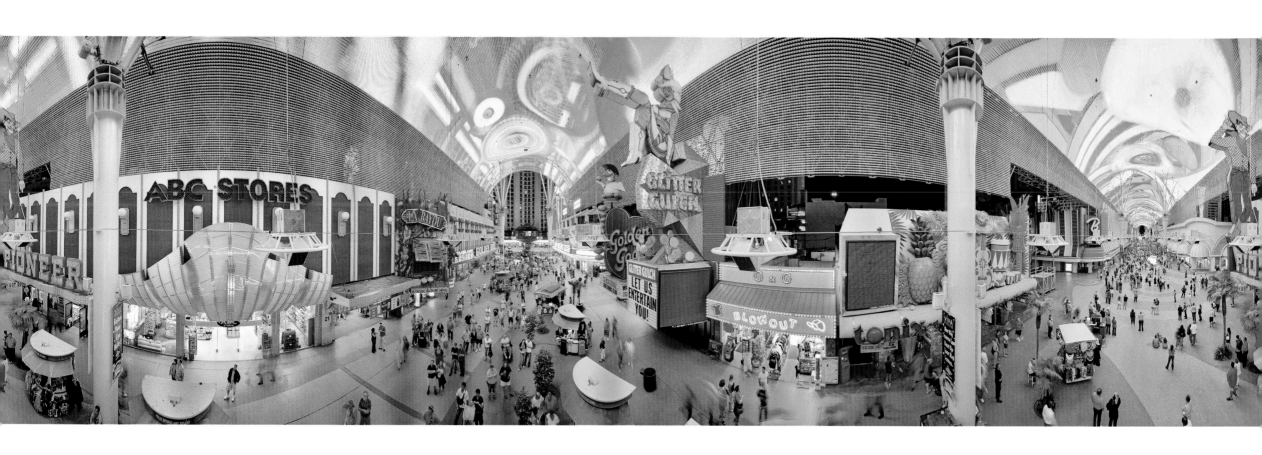

Fremont Street, Sassy Sally, 2006

Bellagio, Fountain, 2006

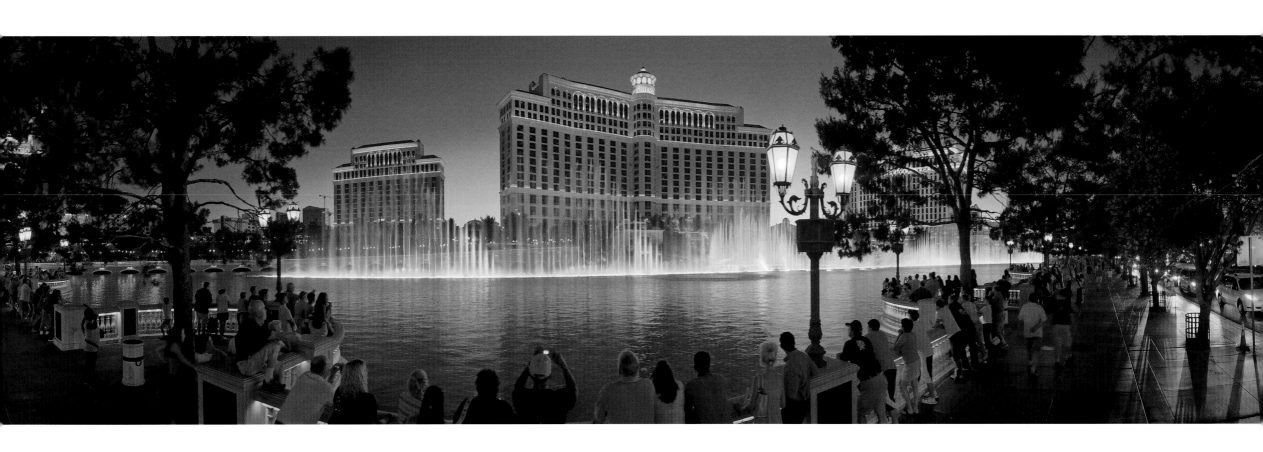

The Strip at MGM, Sunrise, 2006

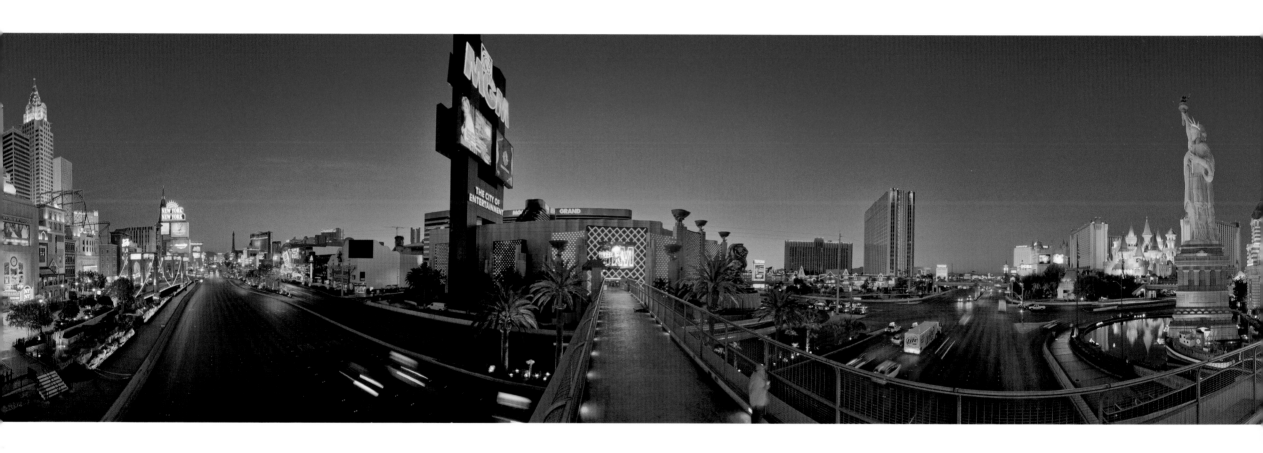

Excalibur, 2001

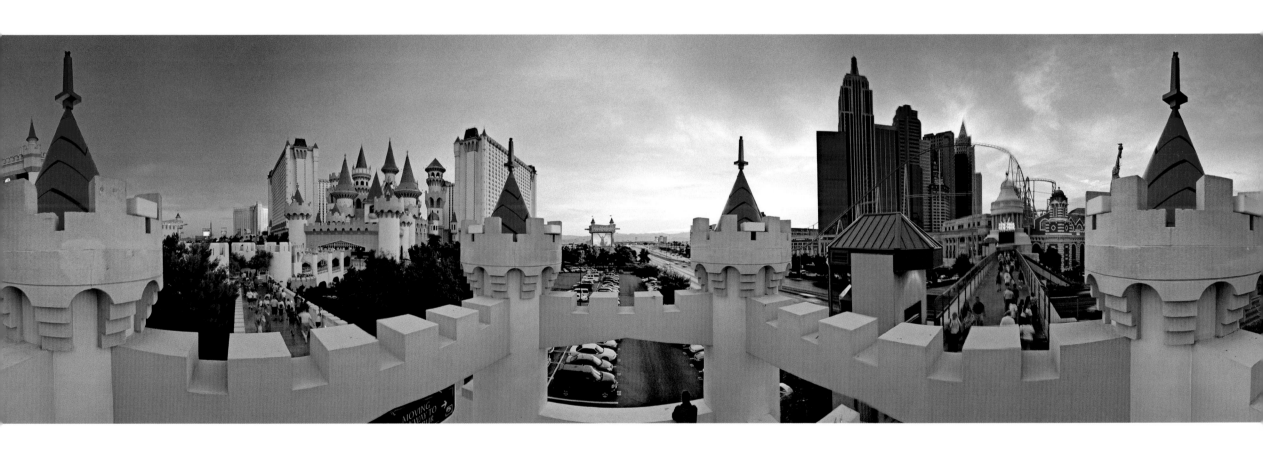

From the Garage at Mirage, Sunrise, 2006

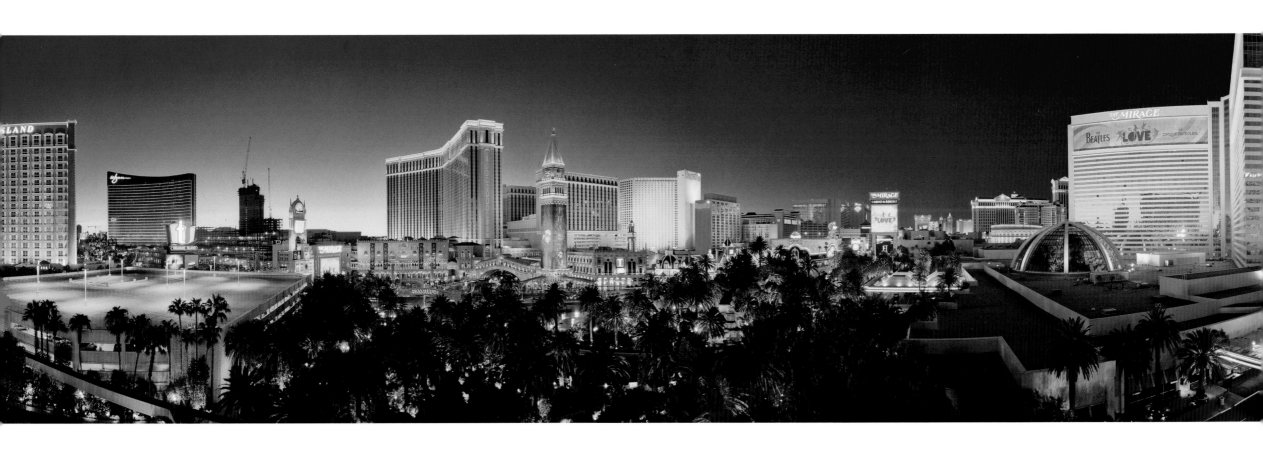

Paris Hotel and Casino, Sunrise, 2006

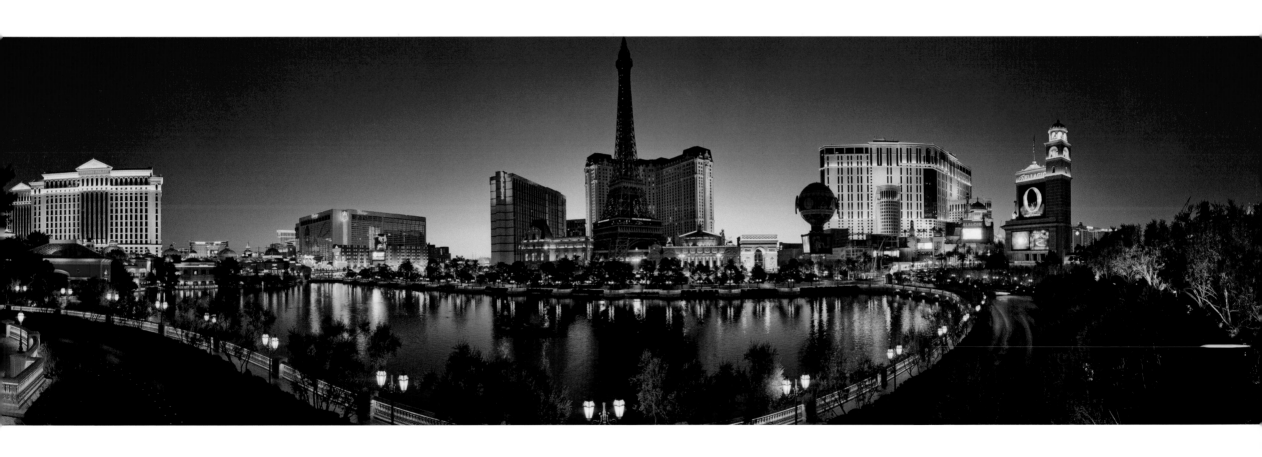

From the Showcase Mall Garage, Sunset, 2006

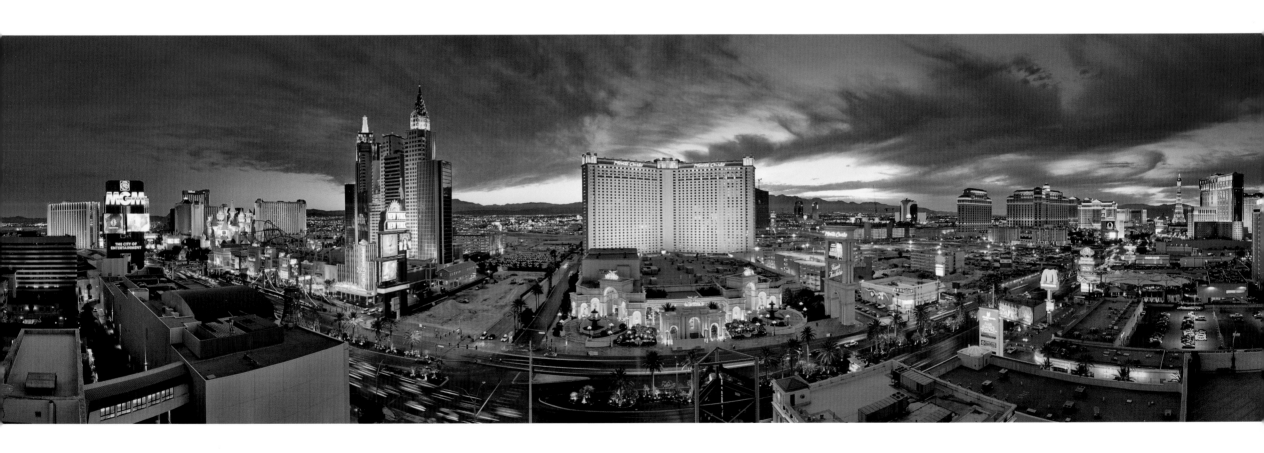

The Strip, 2004

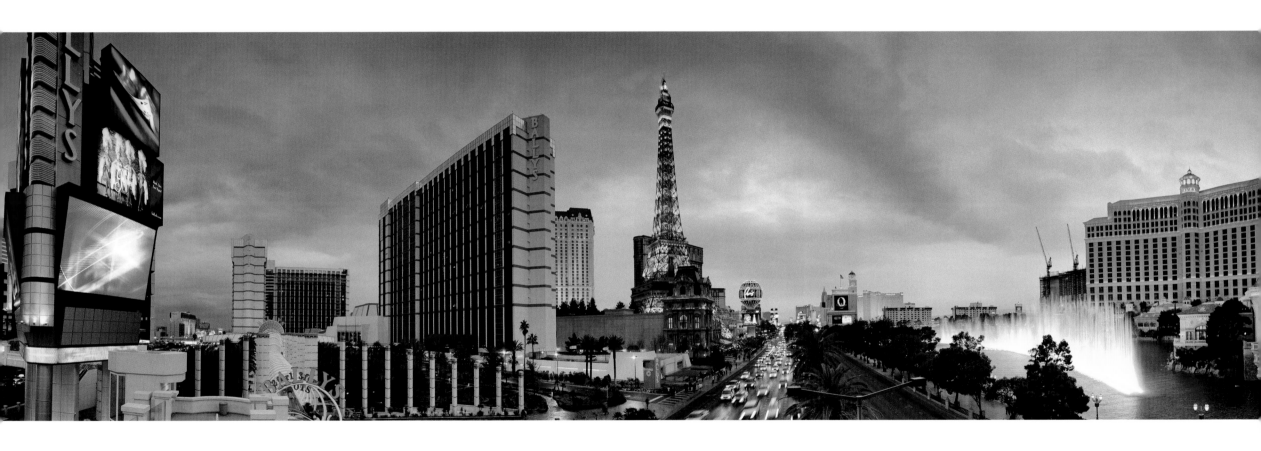

Treasure Island, 2006

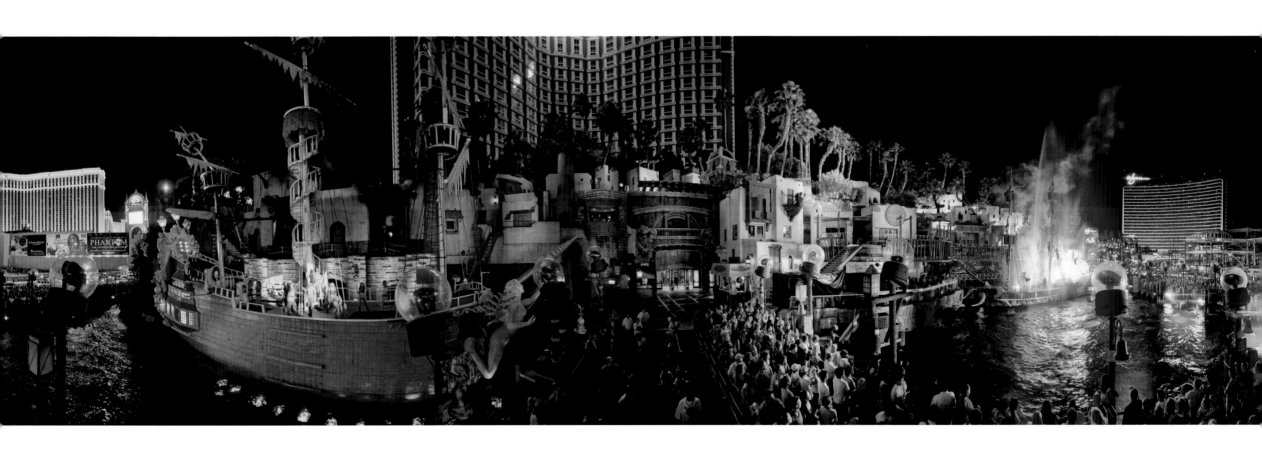

47

From the Voodoo Lounge, Sunset, 2006

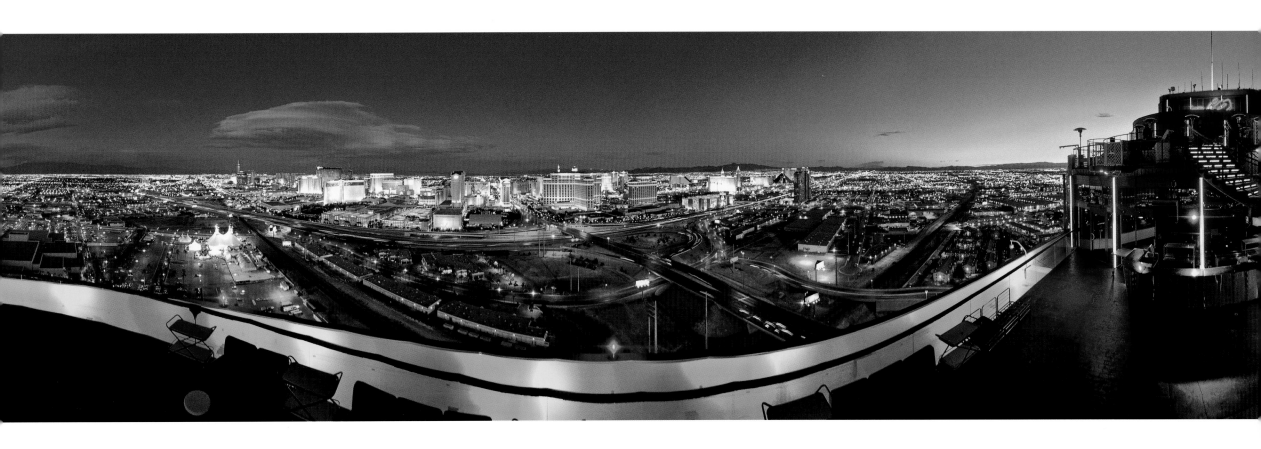

Paris, Arc de Triomphe, 2005

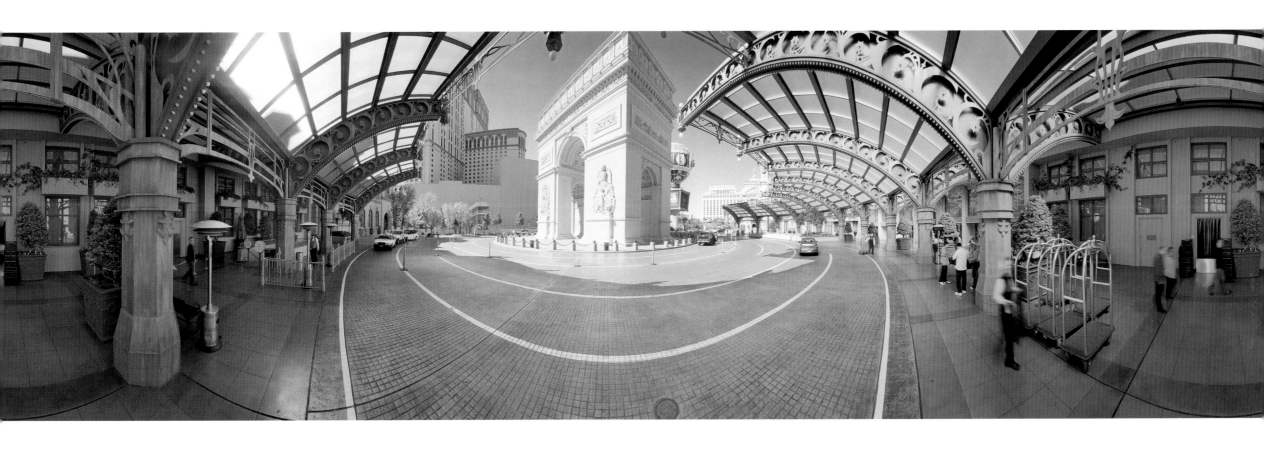

Bally's, 2001

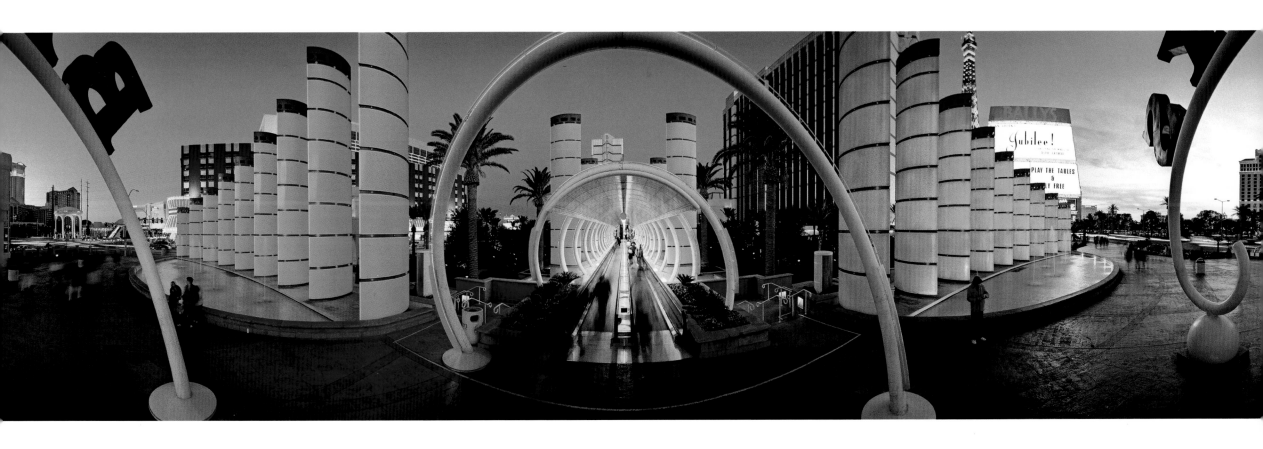

Cruise Ship Vegas Douglas Unger

If Florida is God's waiting room, Las Vegas is God's cruise ship—each day dawns over shifting fortunes and changing seas. In the last years of his life, my father took this cruise, fighting back the fact of his weakening heart by betting on football and other sports. Or he'd play wrong-way dice at the craps tables—reverse Martingale, betting the no-pass line then doubling down on pass after pass until the shooter finally craps out, the table goes cold, and the wrong-way player is the only one left standing.

Craps players hate wrong-way bettors; it's bad juju. Dad felt no remorse—he'd been all but wiped out himself by a complex life beset by three expensive divorces. So he enjoyed a sense of equalizing justice in the way he could approach a happy, high, shout-'em-up gaggle of tourists in a giddy frenzy tossing out the cubes and, with his wrong-way play, triumph as they deflated, flat-busted and hung-over.

If he wasn't having a good day, he'd watch his limit—two grand some days—vanish under a croupier's stick. Without complaint, he'd limp off clutching his comped coupons and player's club cards. He'd chow down on artery-clogging lunch buffets, which made him feel fuller, so better. He drove off in the ancient four-wheeler he'd painted fire-engine red to a mobile home park threatened by impending redevelopment. Still, he would return again the next day.

What did Dad get out of this? Not the gambling. He was smart enough to know the odds. Even betting against losers would end up a losing game. He enjoyed the illusion casinos offered—the action, the crowds, being present in the moment, the staving off of loneliness and boredom—like a last chance at living. For Dad, it was The Golden Nugget, Binion's Horseshoe, Boulder Station when he wasn't so flush; when he was riding an up streak, he'd hit The Stardust, Caesars Palace, or Bally's—which he generally preferred. Sometimes, a pit boss would toss him a voucher for a show. When he died, there were two unused tickets in his pocket to see the showgirls in "Jubilee." So went his routine, every day, day in, day out, until his heart stopped. Among his last words: "Think I'll bet the over-under on the Broncos."

He left instructions, a kind of list: Say goodbye to Ed the valet parker at The Stardust; Joe the day shift bartender at The Golden Nugget; Sally who threw cocktails for the sports book at Boulder Station; and so on, Rick, Mike, Steve, Judy, Rocco—it took two days to make the rounds. These were the people with whom he had shared his last years. This was his real funeral, his burial at sea. Each was moved hearing the news. Sam—a craps dealer at Bally's—took it hard and cried. "He was a real character, your dad. A good tipper, too," he said. Then—on course ourselves—we sailed away.

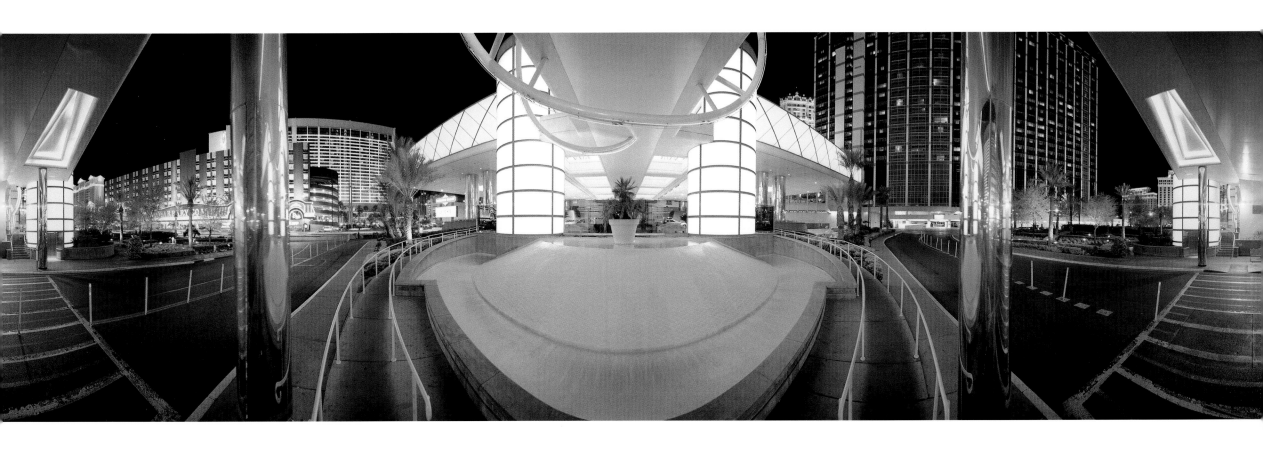

Bally's, 2005

Caesars Forum, Sunset, 2006

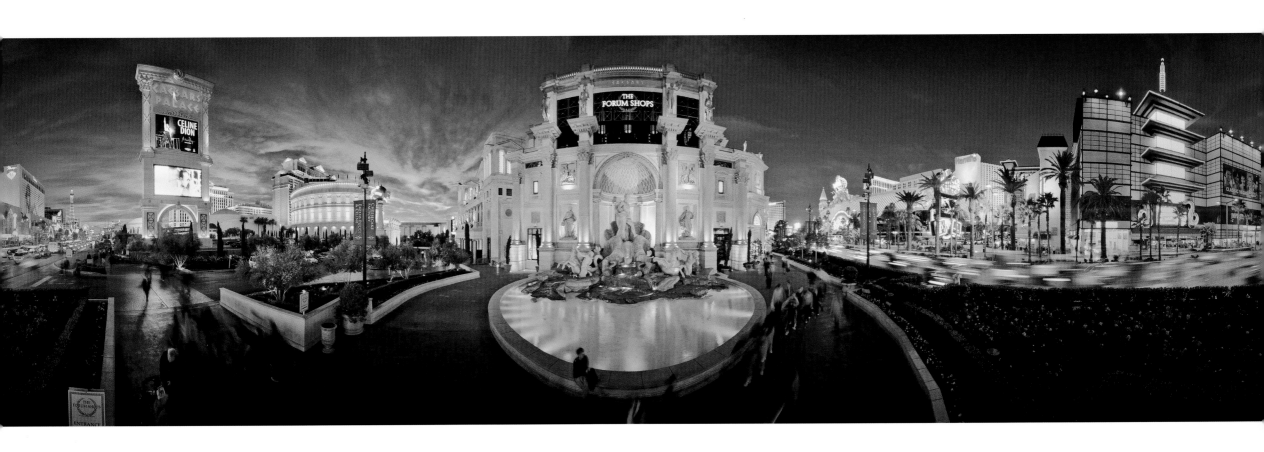

Caesars, 2001

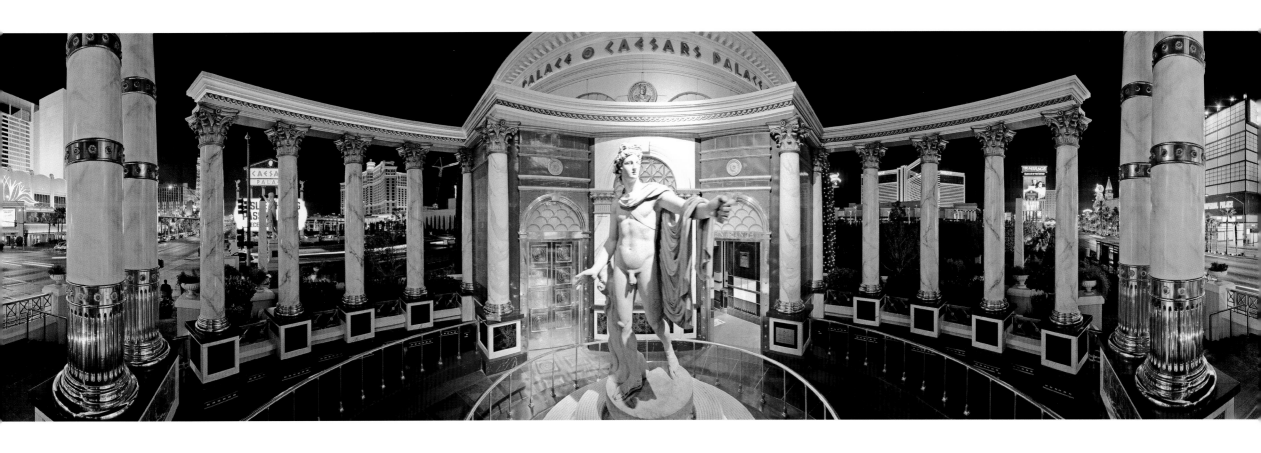

59

Caesars, the Pool, 2006

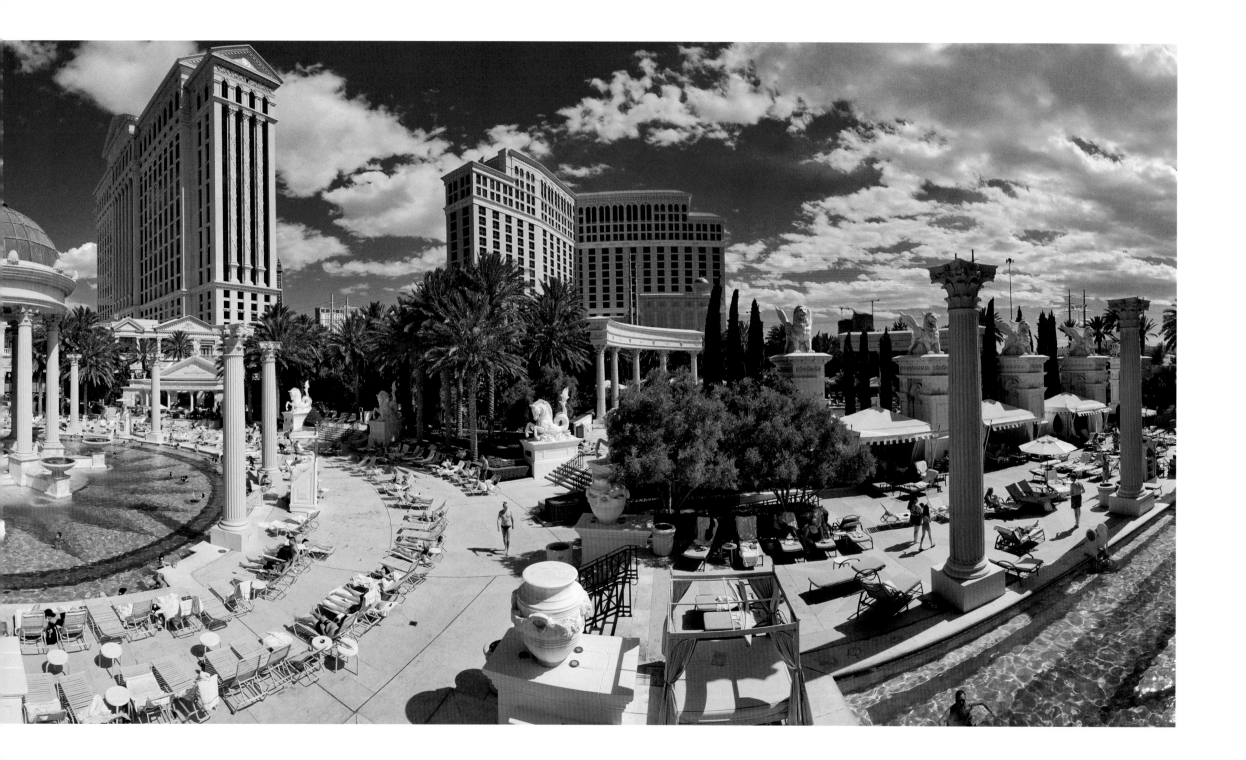

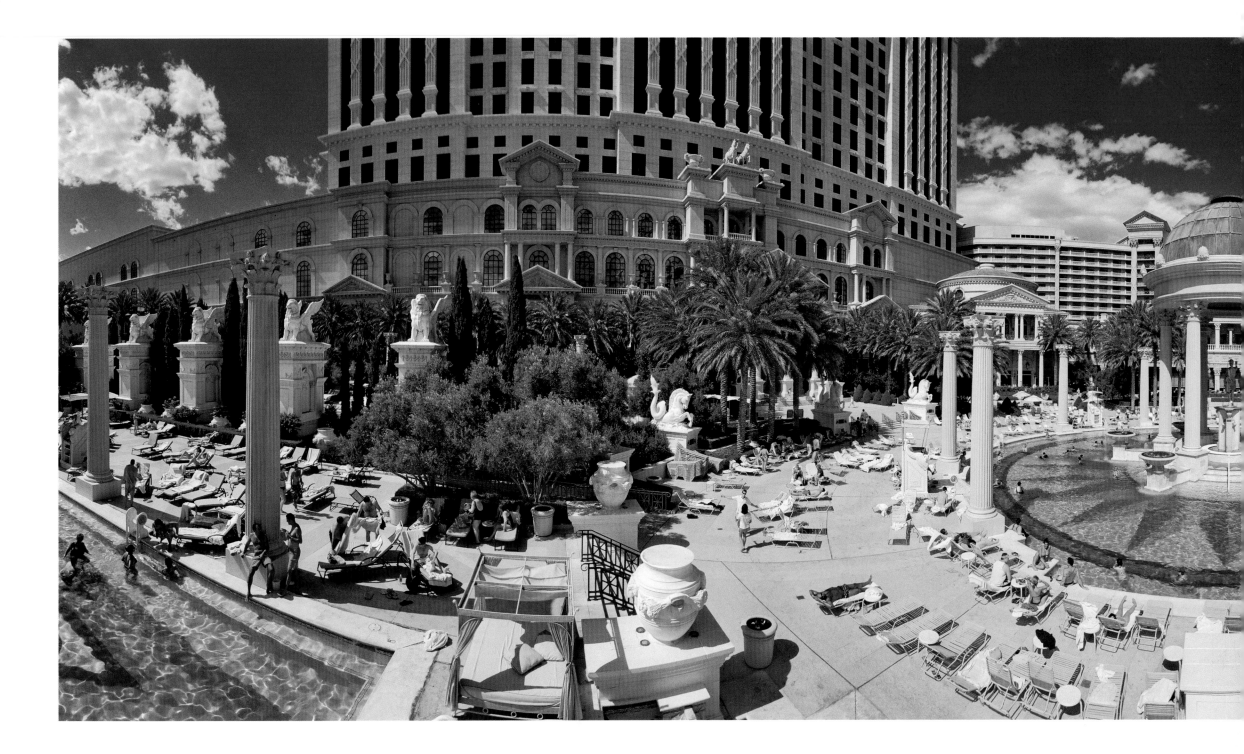

GameWorks, Sunrise, 2006

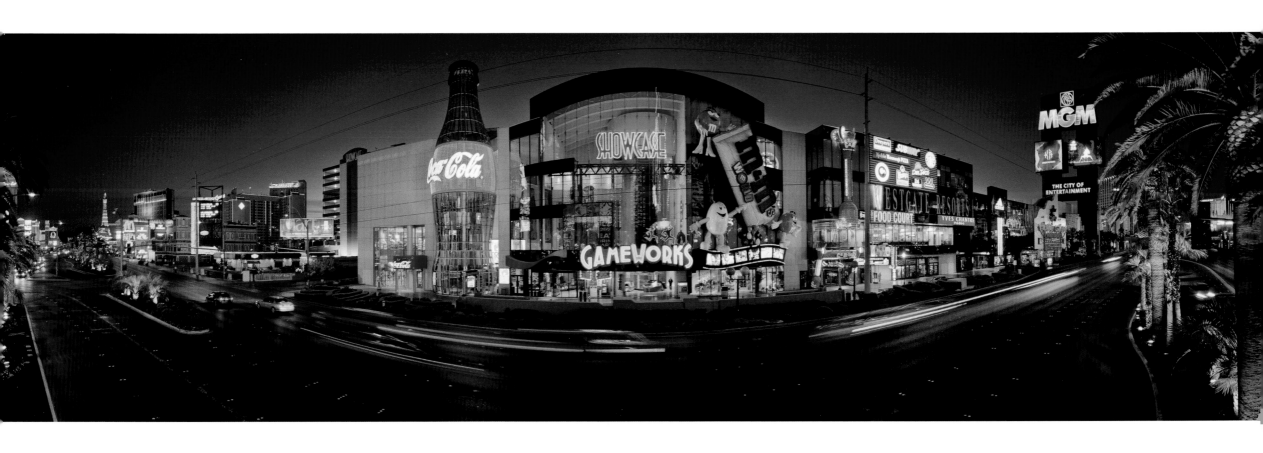

Harrah's and the Forum, Sunset, 2006

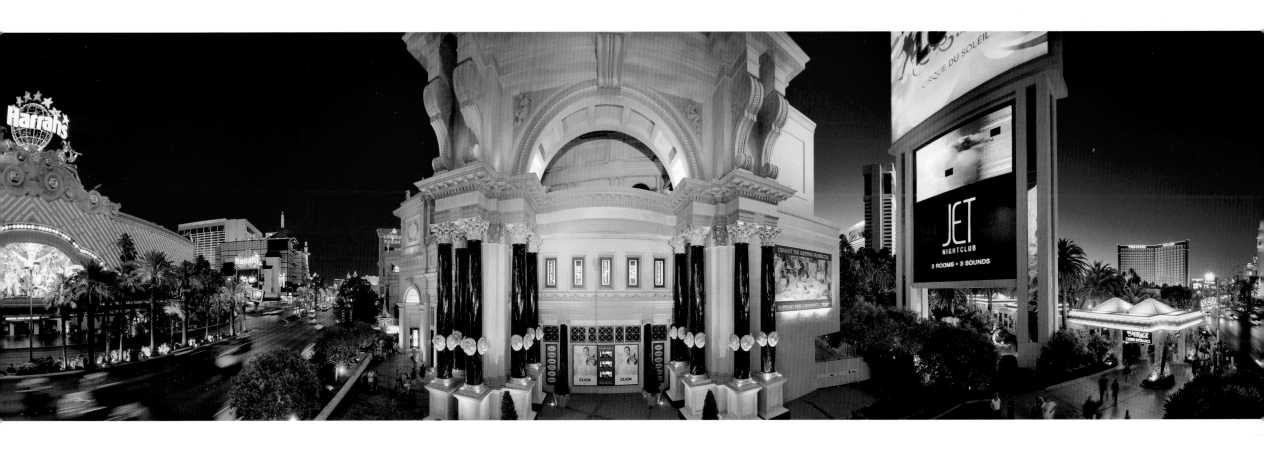

Holiday Motel, 2006

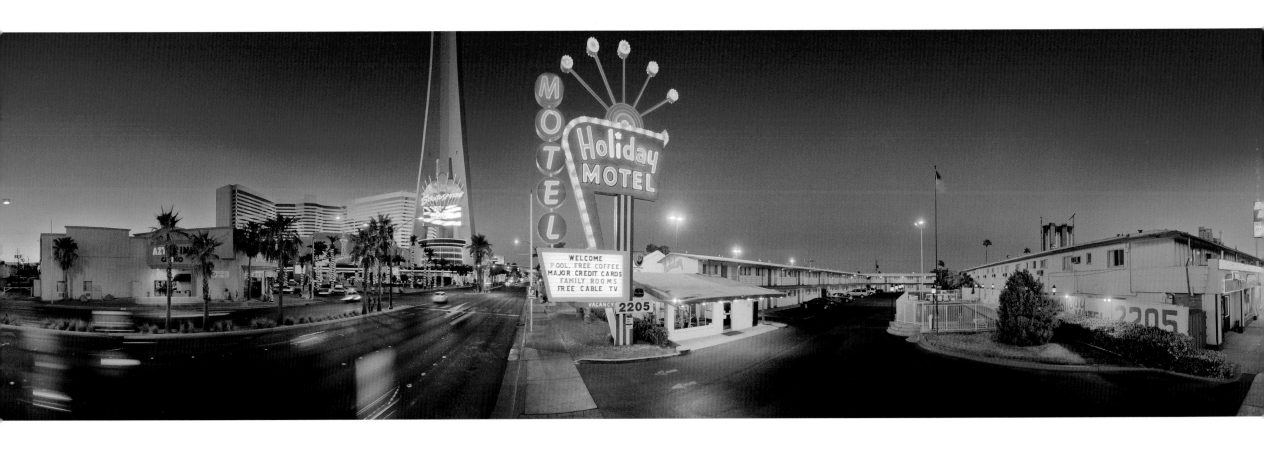

McDonald's, 2005

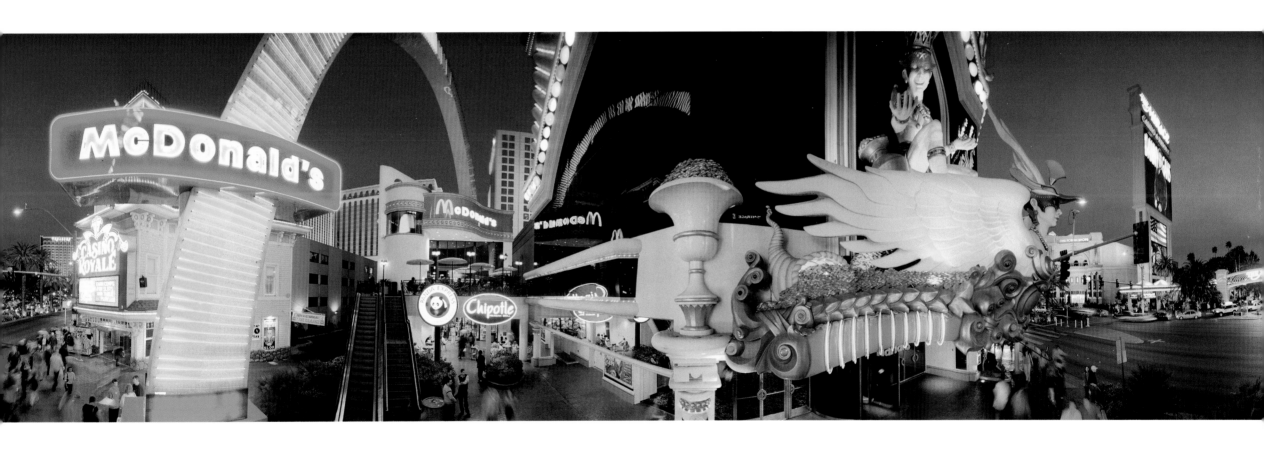

MGM Grand, 2004

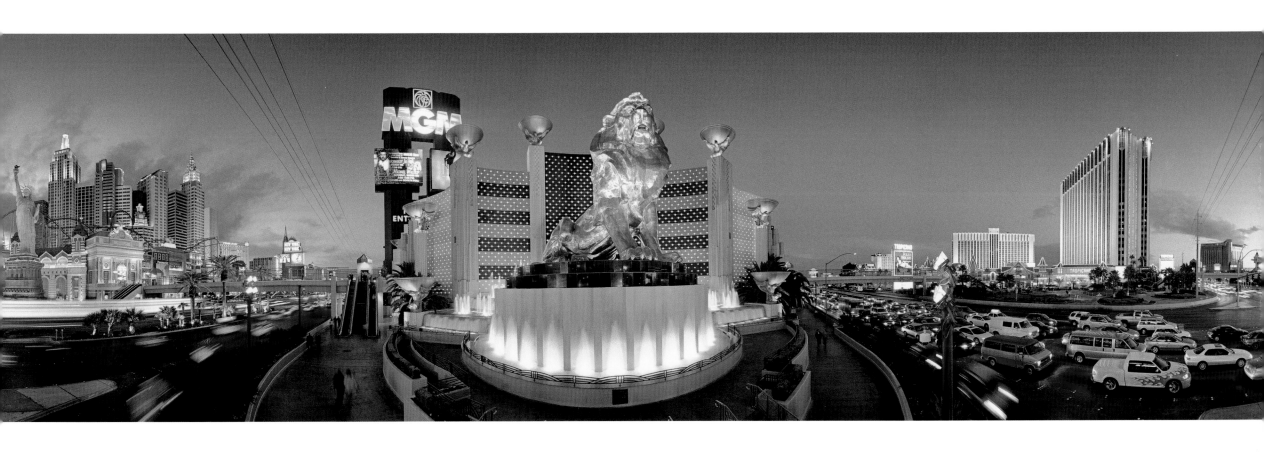

The Mirage, Volcano, 2006

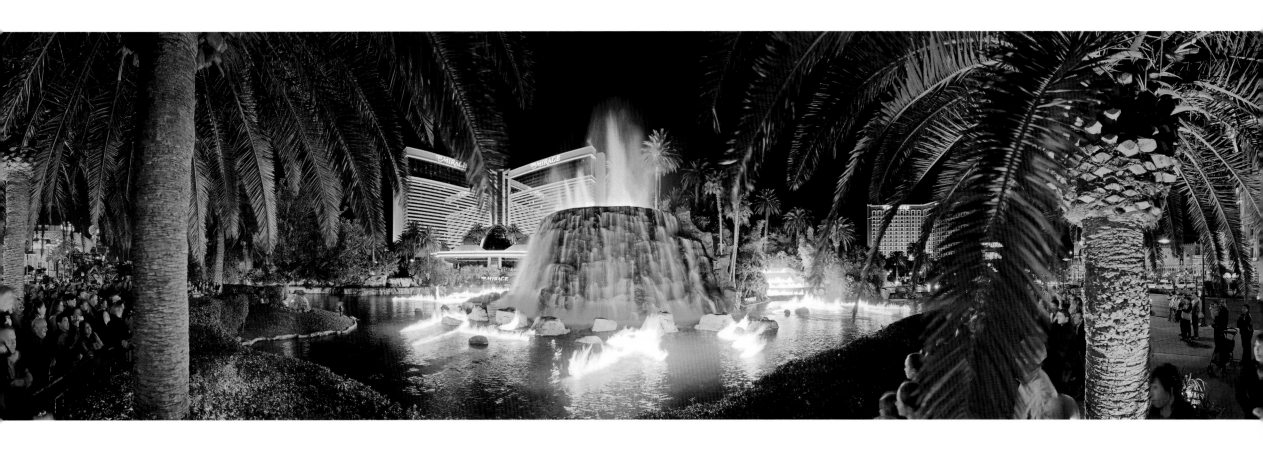

Same Time Next Year? Kim Thomas

Every New Year's Eve but one for the last fifteen years, I've worked the Strip. Meaning no boogying at parties for me, no kissing scantily-clad women I've never seen before and won't see again, no throwing confetti and whatever else from the balcony of a dance club, no getting knee-walking drunk and making a fool of myself however much I'd like to. Nope, none of that for me. My job every New Year's Eve but one has been to try to keep a lid on things. As if.

Since I've been a cop, the one year I didn't work the Strip on New Year's was the one year I was so deep undercover, I didn't dare. I was ordered to sit it out at home, and so there I sat that one miserable New Year's, planted in front of the TV, a bowl of popcorn on my lap, asleep long before midnight.

So what's the attraction of the Strip for a cop on New Year's?

It can't be the drunks, the fights, or more drunks and more fights, or the drunk young women baring their tops, or still more drunks and more fights, or the fool who dove head-first off a light pole one year assuming, disastrously and incorrectly, that the folks below would catch him, or the couple I had to bust one year for having sex on top of a bus stop shelter, or—hard to imagine—still more drunks and more fights.

The Strip has become the nation's number-two New Year's destination, after Times Square. Every New Year's, a quarter million people, most of them young, most of them drunk, come out to stand in the middle of Las Vegas Boulevard and do what drunk young people have probably always done since our ancestors first discovered the joys of fermentation.

So, again, what's the attraction?

I still remember vividly my first New Year's on the Strip: wading into the middle of a brawl with my comrades, trying to contain it. I remember having it out with two drunks, my hands full of their lapels, them doing the slugging—on me—until I was pepper-sprayed by one of my own partners. First blinded, then cold-cocked, I ended up on the ground, where the drunks proceeded to stomp my ass while someone in the crowd, maybe a drunk schoolteacher from Des Moines or drunk stockbroker from Milwaukee or drunk truck driver from Fresno, tugged at the gun in my holster. I remember then how security officers from Harrah's rushed out of the casino and rescued us, and how I came to my senses sitting on the tailgate of an ambulance, having my face and eyes washed of the orange-dyed pepper spray while I listened to the crowd count down the seconds to a new year, and how just then, of all things, I was trying to remember a line from Walt Whitman's "One's-Self I Sing"—still a bit loopy from the beating, I suppose—while blood slowly dripped into my stinging eyes. That line from Whitman, something about "Democratic" and "En-Masse," and I'm thinking of the glorious, absurd democratic chaos of it all. "My god," I mumbled through cut, swollen lips to the cop sitting next to me having his own cuts tended to, "I can't wait until next year."

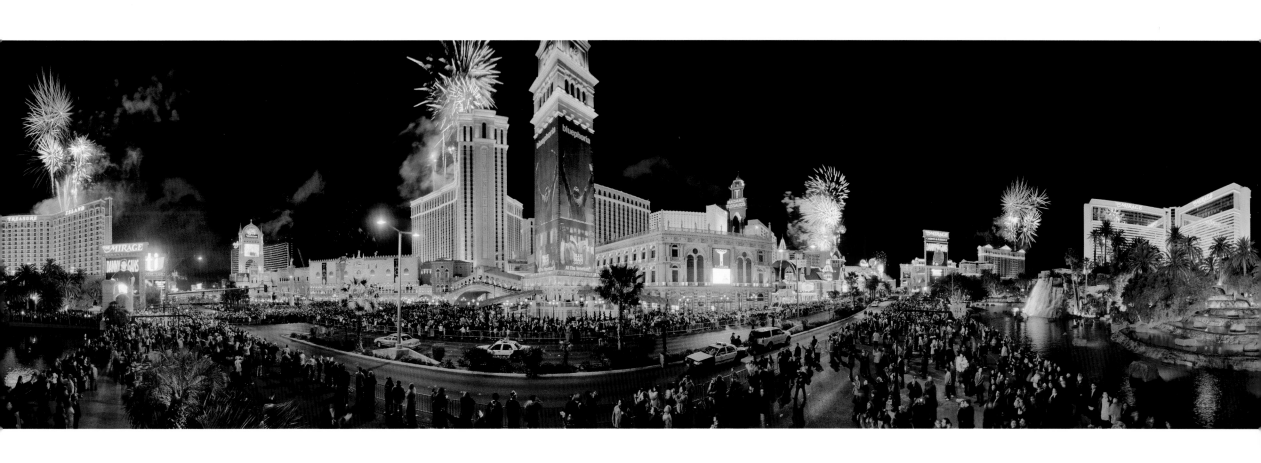

The Strip, New Year's Eve, 2006

Neonopolis, 2006

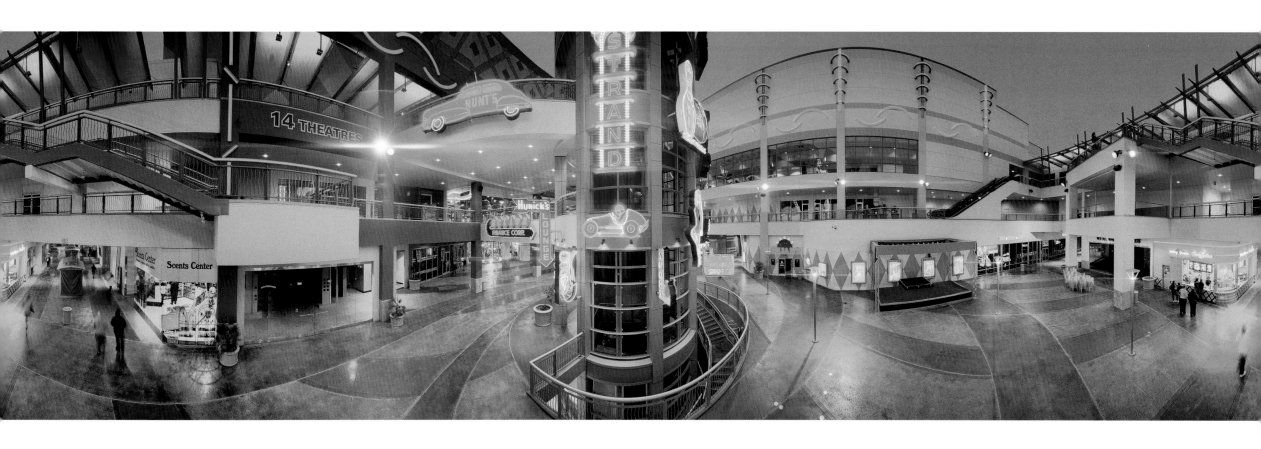

New York New York, 2004

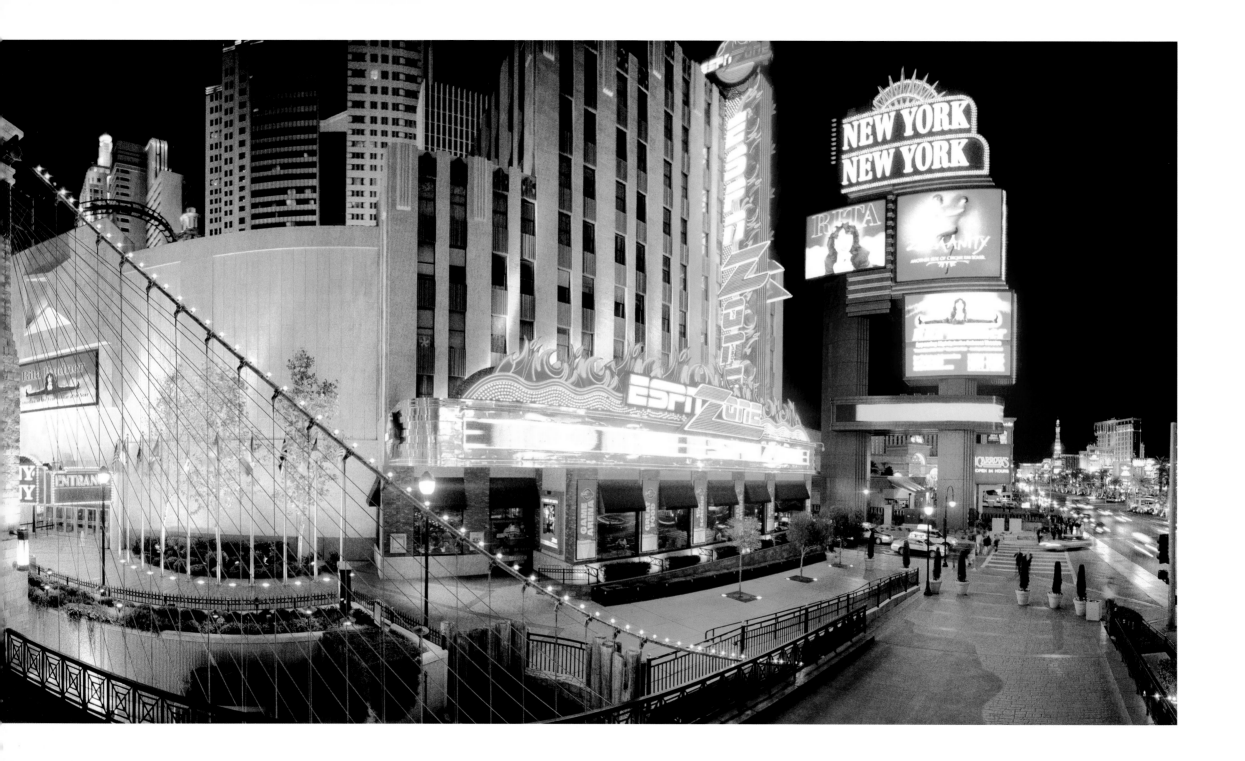

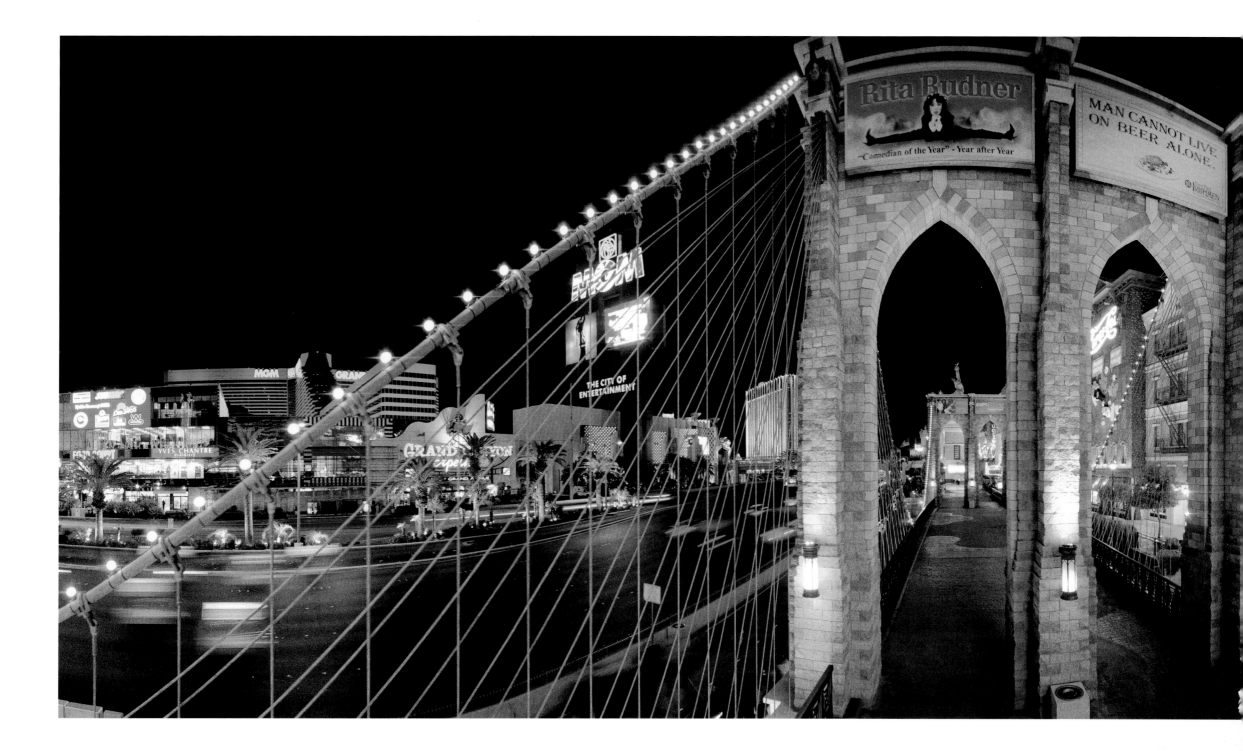

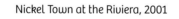
Nickel Town at the Riviera, 2001

The Venetian, 2001

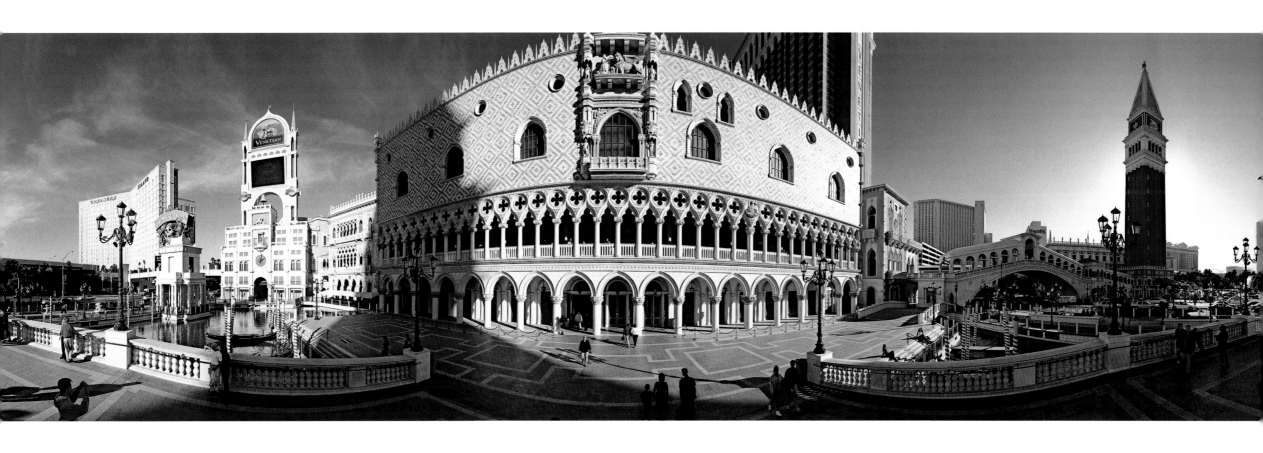

The Fabulous *Fabulous* Las Vegas Sign Phil Hagen

When Betty Willis inserted the word "Fabulous" into her "Welcome to Las Vegas" sign, it was in the spirit of how she felt about the place then. And no one will tell you that she didn't nail it.

But the odds of that particular word sticking around were low. Times change everywhere, always. And then there's the Las Vegas Strip.

The sign first went up on the southern edge of Las Vegas Boulevard in 1959, at the height of the Rat Pack's reign and pretty much everything else that made mid-century America cool: the automobile, the neon sign, Googie architecture, postwar optimism, a young and thin Elvis. And the destination to which you were being welcomed was a fabulously hip and sunny fusion of those ideals without the daily grind of the truth.

Through the years, the Strip has remained a sort of funhouse mirror of American culture, the most mutable commercial corridor on earth. Today it's a baroque amalgam of ideas old and new, from medieval megaresort to lean urban chic. And everybody—everybody who counts—agrees that the place is still fabulous, even though little of it resembles the Vegas that inspired Willis.

The sign still works, and not as a mere relic. The sign still works by having kept its distance from the Strip's southward expansion. Aesthetically it works best by itself along a desert highway, and pragmatically, well, there's no point to a welcome sign if you're already *in* the place.

The downside is that we now bypass the southern approach, and the sign, on our way into Vegas.

So, you have to make an effort to get down to the sign these days, and, for better or worse, flocks of us do, because it's one of the last photo ops that truly certifies your Vegas vacation. But Willis' design wasn't meant to be parked by and gawked at from a gravelly median. The Fabulous Las Vegas sign, at 25 feet tall by 20 feet wide, was built for speed. And in the dream, you come upon it around dusk, so that this twinkling little burst of anticipation is set against the remnants of a western day, and you breeze into the ultimate desert oasis just as it's powering up for a long night.

But Willis' sign endures apart from its seductive welcoming quality, because its physical form long ago transcended roadside function. One of the most incorporated icons since the Statue of Liberty, the Vegas-style greeting shows up everywhere from inside snow globes to covers of personalized wedding mint tins, because the design itself is truly fabulous.

All of Willis' elements work together as a kind of organized chaos. And in the center of it all the word "Fabulous," which is purposely not the biggest word—but is the most stylized.

Flattery in the form of imitation may be sincere, but Vegas does it all the time. Not being able to reinvent something that defines it? Now that's almost impossible to believe.

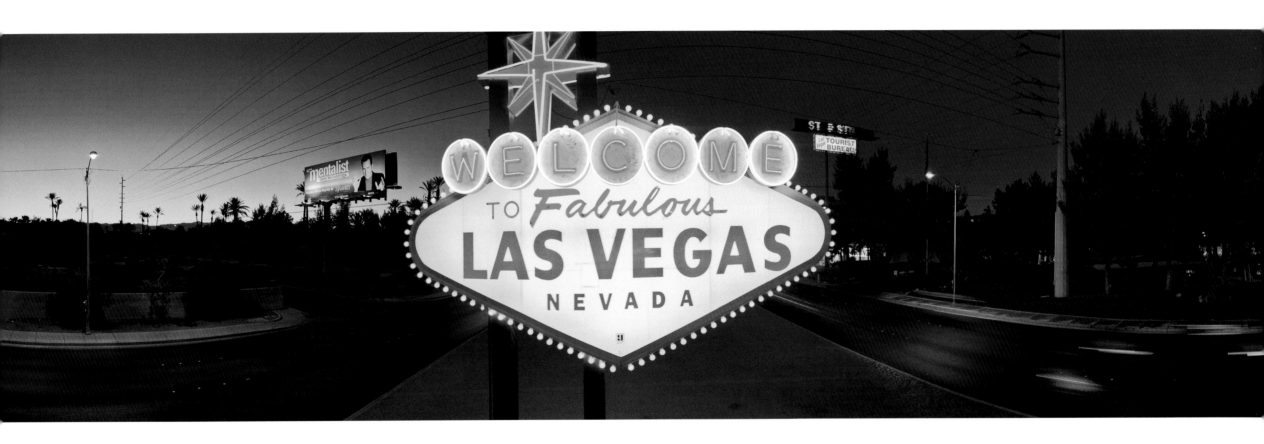

Fabulous Las Vegas Sign, 2006

Wynn Las Vegas, Esplanade, 2006

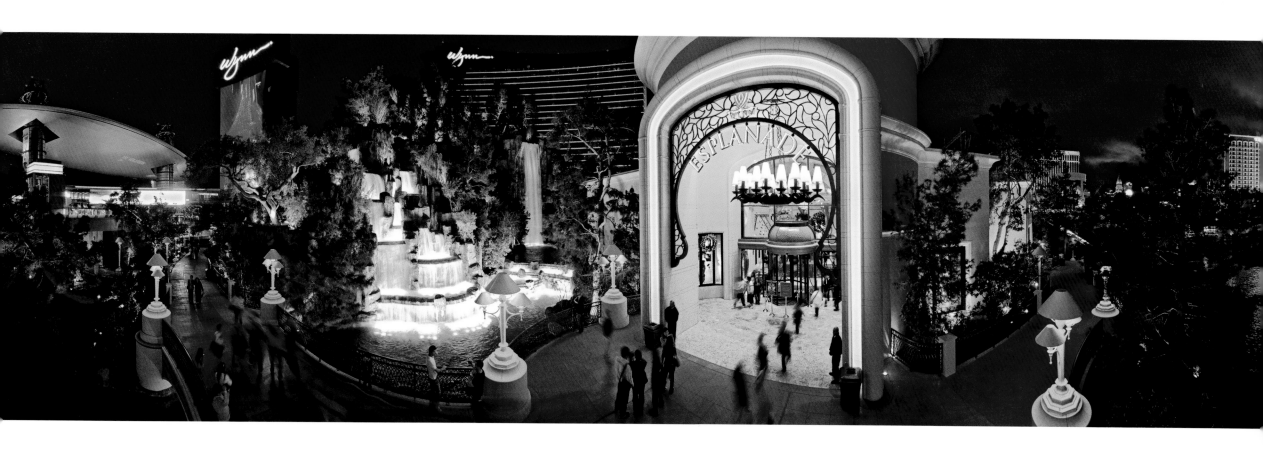

The Adventuredome, 2006

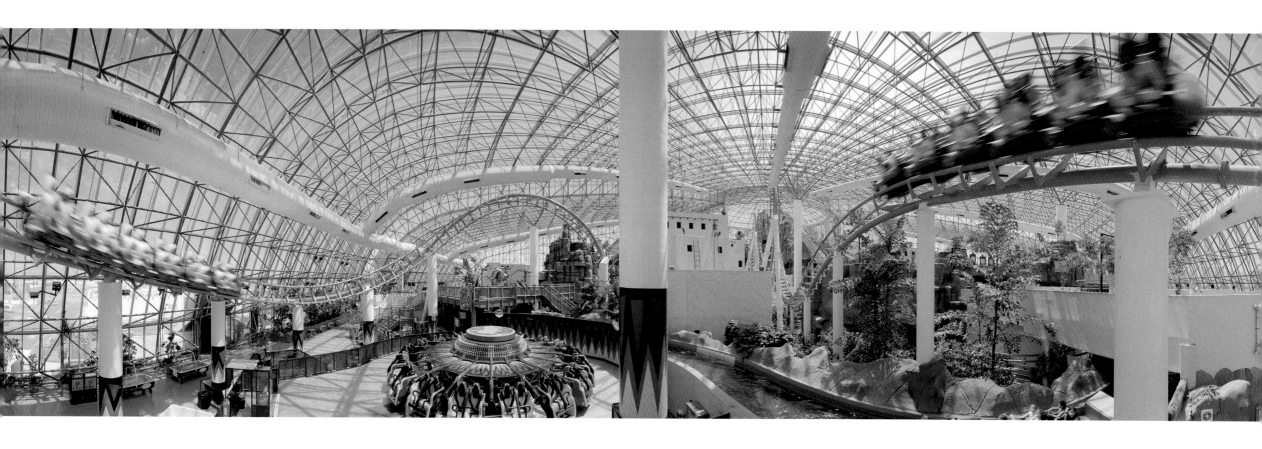

Aladdin, Desert Passage, 2004

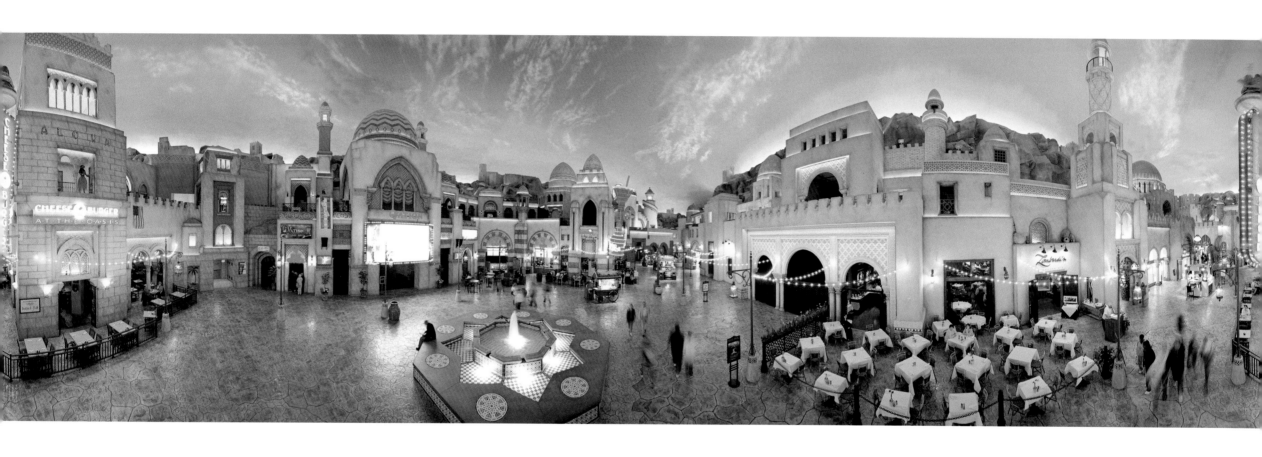

Bellagio, Conservatory, 2005

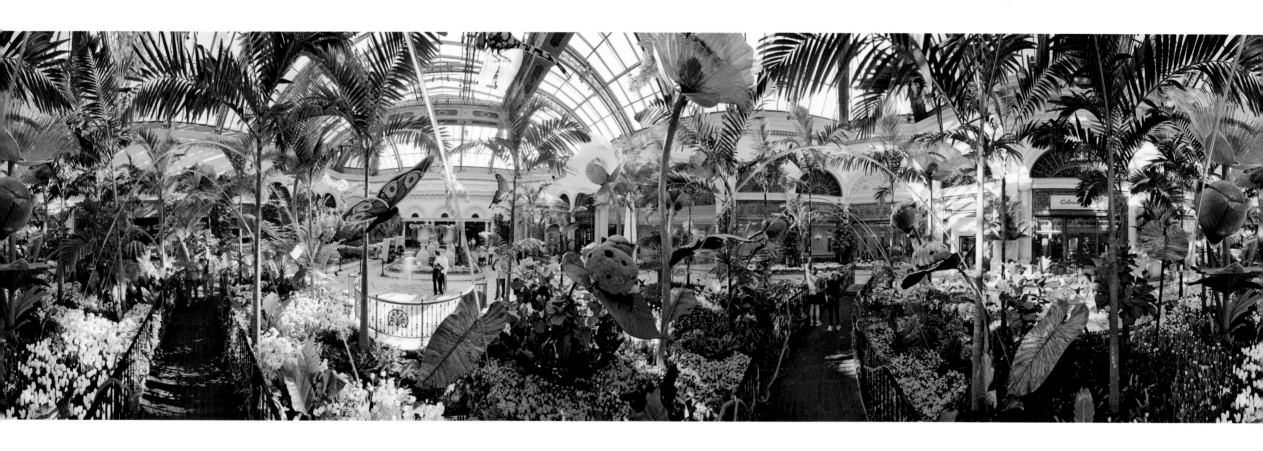

Caesars, Mesa Grill, 2006

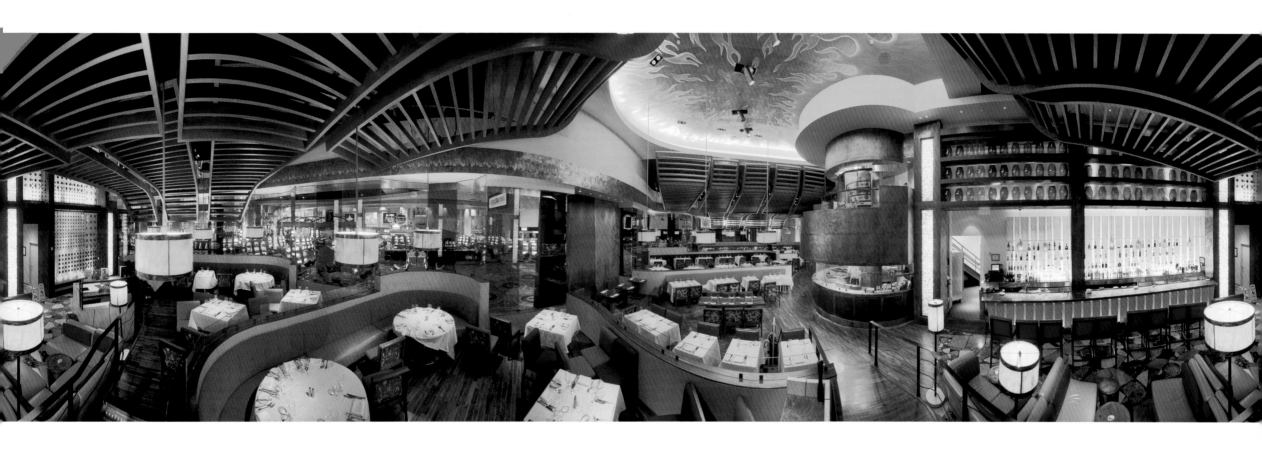

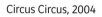

Circus Circus, 2004

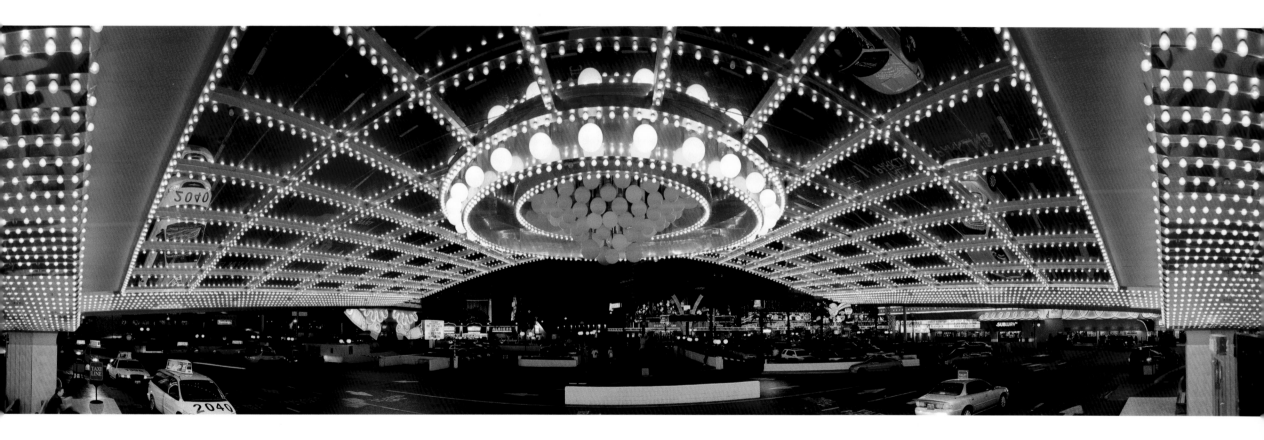

Bellagio, Conservatory, 2001

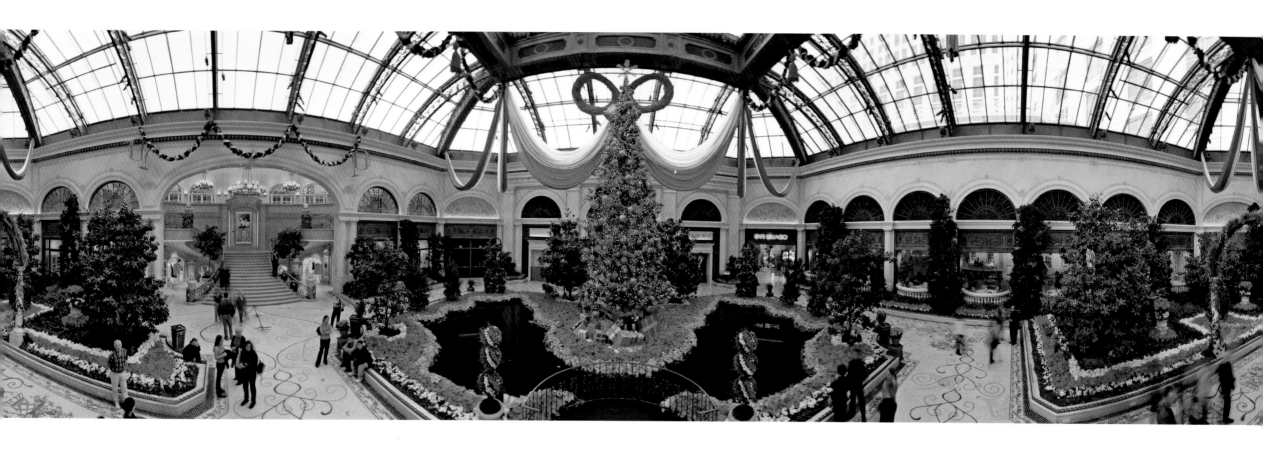

NASCAR Café, 2005

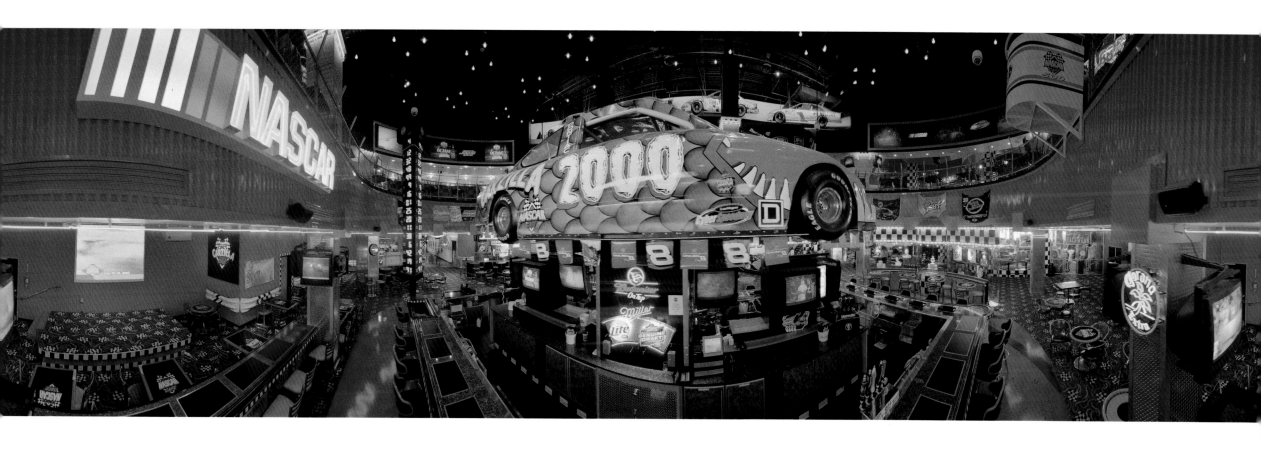

New York New York, Interior, 2004

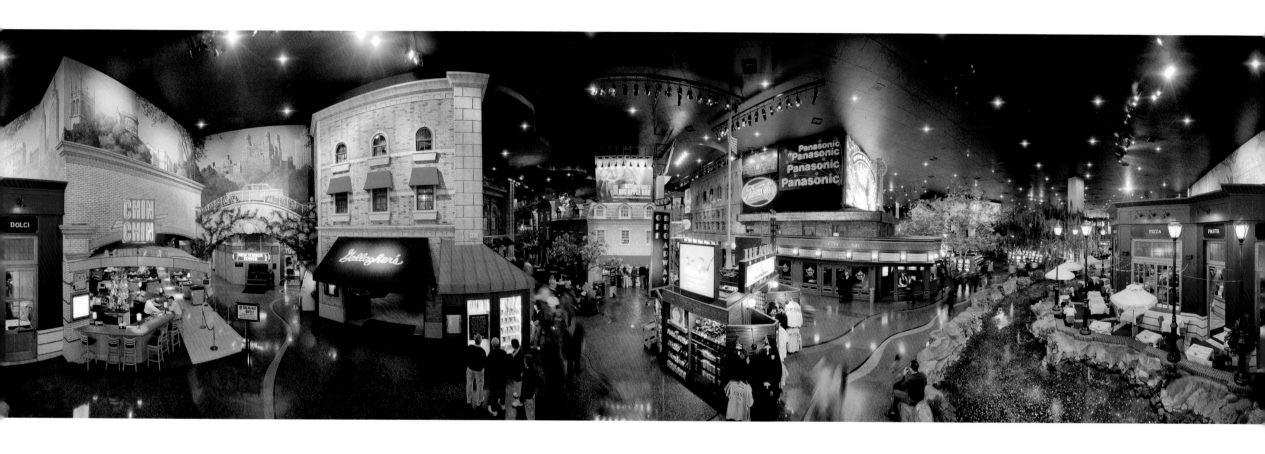

Paris Hotel and Casino, 2006

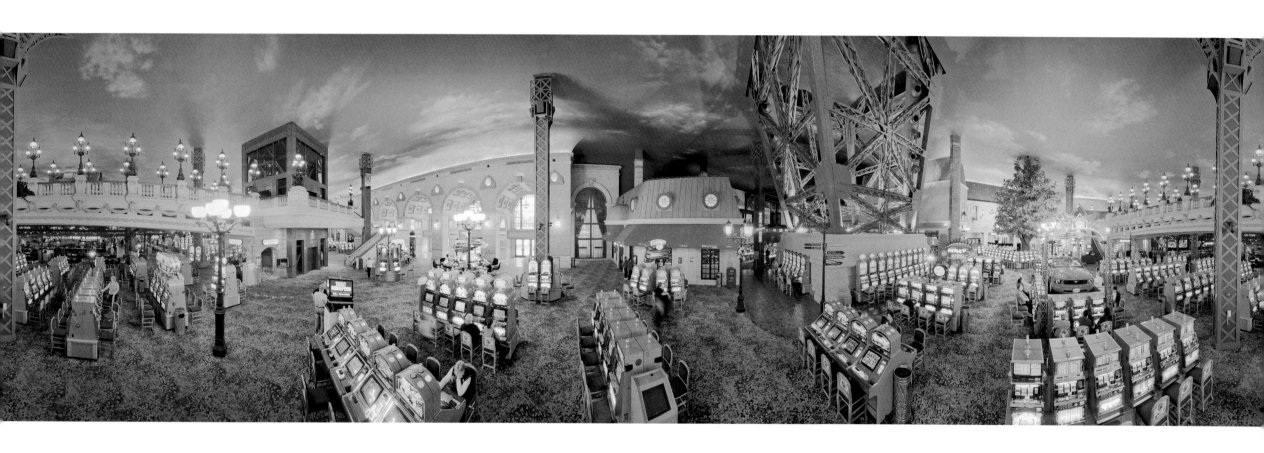

The Show-Off Must Go On
Benedetta Pignatelli

Be warned if you plan to love Las Vegas. It will love you back with a vengeance. I don't mean the hordes who love it for the weekend or the "trikend" (the much beloved three-day holiday), those who mistake express gratitude for Love. I mean the ones left standing and wanting, the ones who dare reside, and eventually dare to *live*. Las Vegas may be the lone geography where one is best served by flawed senses: a little color blindness, perhaps, to tame the Pantone beast. If all your five are vigilant, you're gonna be royally screwed and then royally flushed.

I still went ahead and loved Las Vegas, the house that always wins. It made me do things one does for a decisive lover: I lived here incognito for a full year, while my flock of insta-judgers thought I still resided on Manhattan's Upper East. And to this day, four years later, Las Vegas lets me know when I'm due back from my travels: Its plateau of tolerance for my on-the-road stints seems to clock in at 15 days. It does give back aplenty, though, lets you in on a few Family Secrets if you're slightly observant, nothing sacred. We're talking Las Vagueas, land of the clinically vague or Las Vogueas, the newly appointed backyard of luxury.

Yes, I love Las Vegas, and not because of its Cirque du Soleil superhighway or its Michelin-star-heavy culinary galactica. I love it because a local paper entitled a food section "Last Meal" and it went down smoothly. I love it because of its Eugene Delacroix clouds before the storm and because I've tasted the Western Special at Luv-It-Custard. Because we have two Eiffel Towers, one for public consumption, the other for private viewing that requires privileged access to the grand foyer of the home of timeless chanteuse Phyllis McGuire. Because it is a cultural sleeper and one day it will host "Art Basel Las Vegas" and "La Biennale di Venetian." Because it already hosts the Dairy Queen Operators' Association and the Vinegar Institute conventions. And because my Italianate aesthetics find ocular justice in the replicated athleticism of Michelangelo's *David*, who leads the way to engaging the Forum Shops at Caesars Palace, our very own Goliath of consumption.

Life in Las Vegas is like a movie where someone yelled *Action!* but no one yelled *Cut!* Las Vegas is also the adoptive land of my ideal father: Wladziu Valentino Liberace, so I carry a hard torch for the Liberace Museum, the receptacle for all things Daddy, that has been blessed by the Gods of reflection (not of the Socratic kind). Many a night I've dreamt of falling asleep on Daddy L's Norwegian silver fox stole, while he strokes my cheek, that ever-familiar cold soupçon of 115,000 carat Austrian rhinestone briefly beautifying my skin, "Brahms' Lullaby" playing loudly in the background.

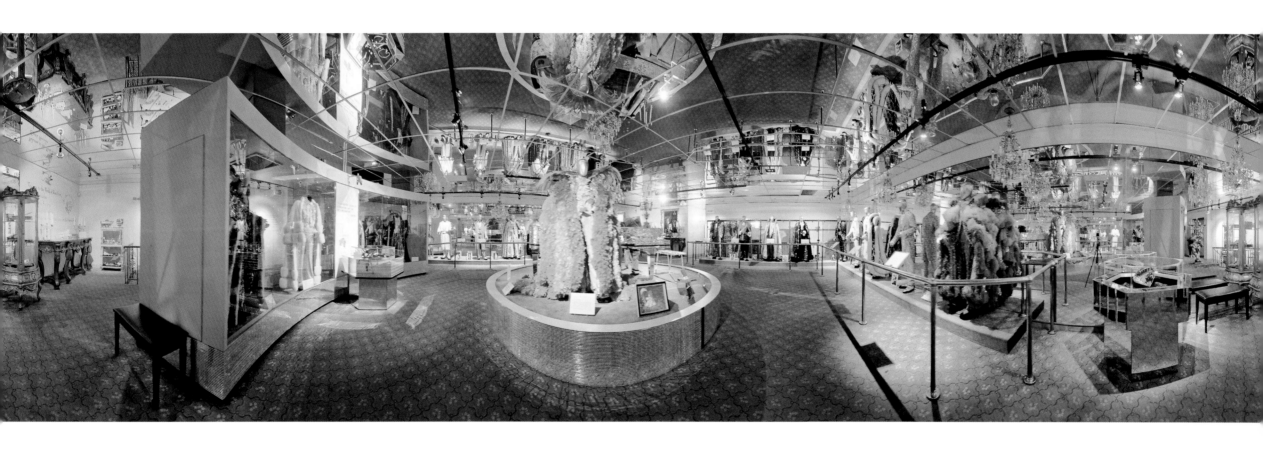

Liberace Museum, 2006

Paris Hotel and Casino, 2005

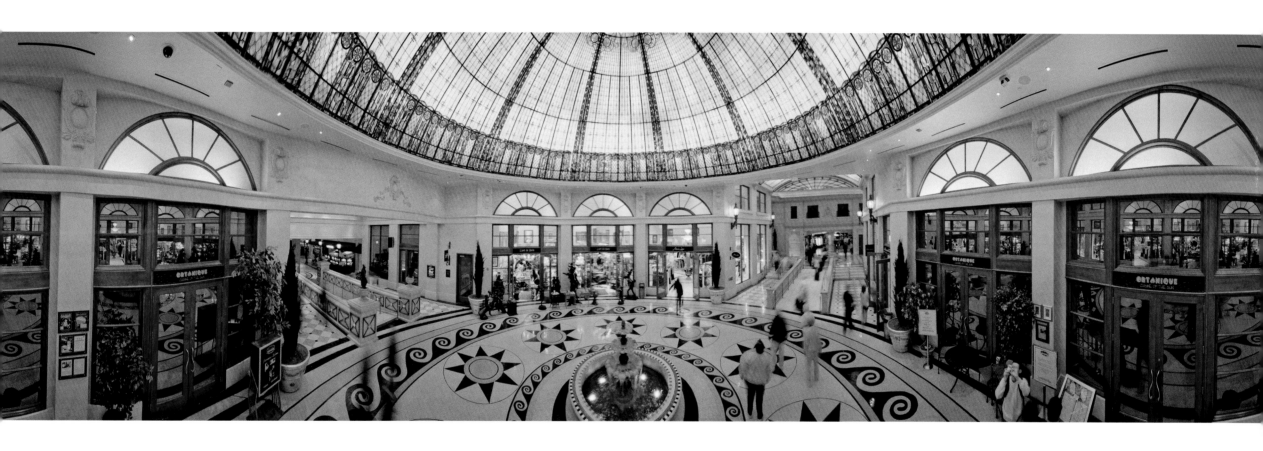

Plaza Hotel and Casino, 2006

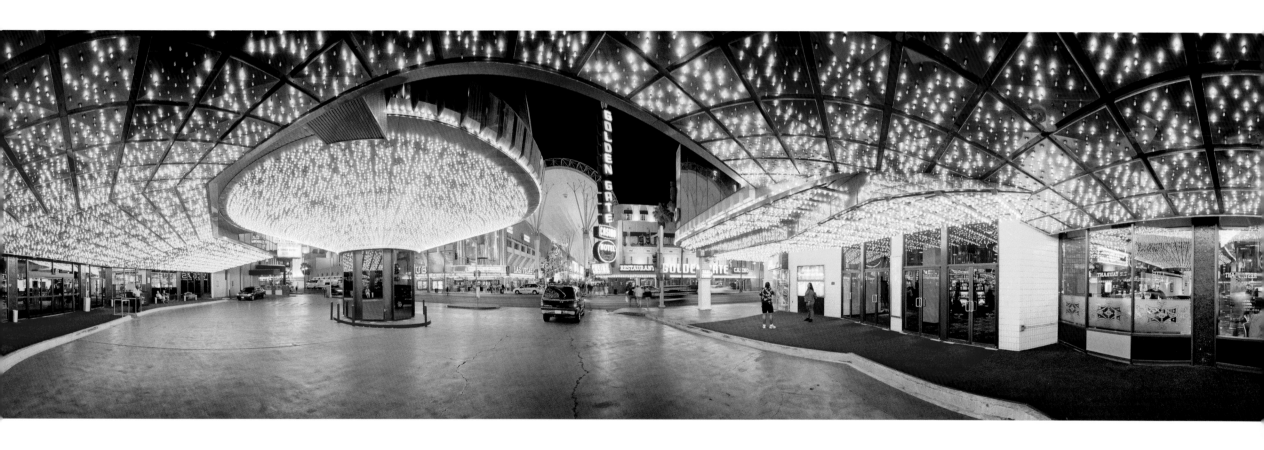

Fremont Street, Souvenirs, 1999

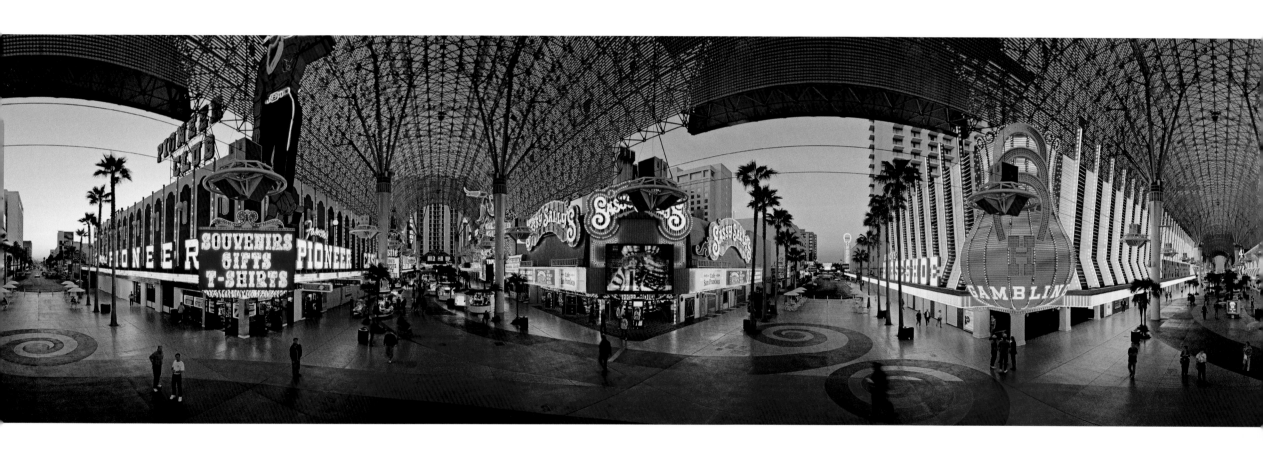

The Venetian, Canal, 2001

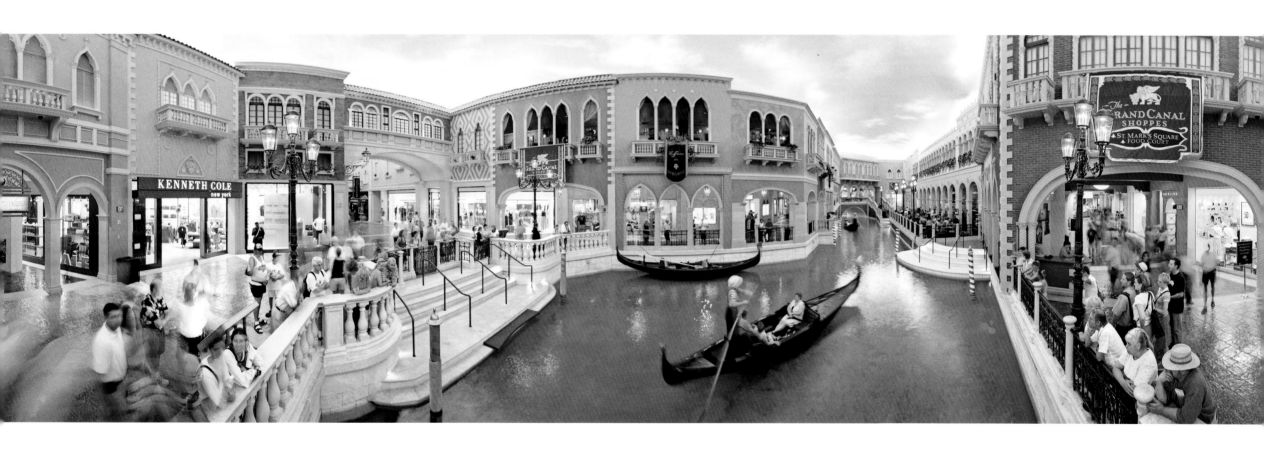

Caesars, Fountain Rotunda, 2004

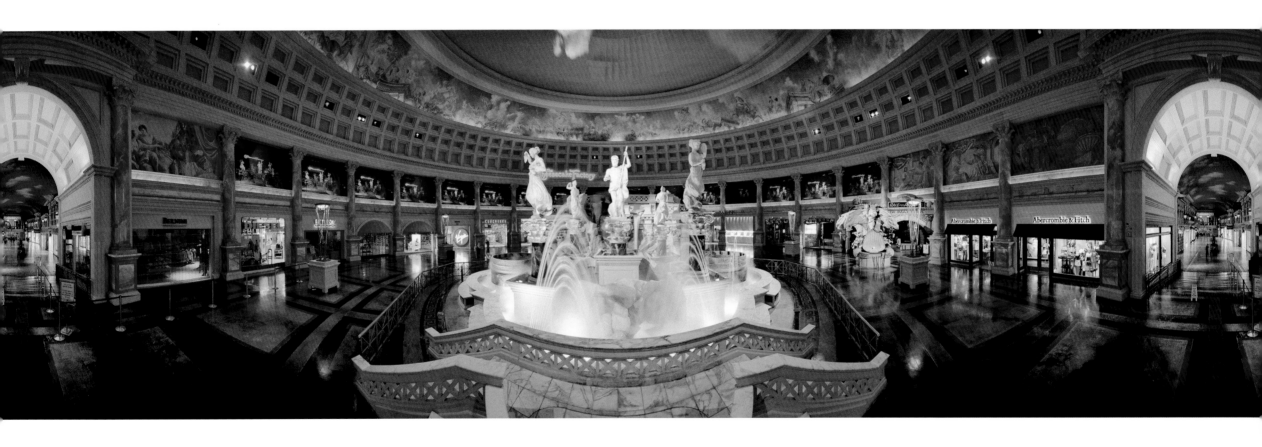

Beneath the Neon Matthew O'Brien

Thirty feet beneath Caesars Palace, in this old and crumbling storm drain, the view is all the same: perfect black. Mildew tinges the air. There are thousands of people somewhere overhead—pulling slot handles, shopping at Versace, tugging on cigars in the sports book—but all I hear is dripping water.

I cut on my flashlight. Carpet, blankets, and tennis shoes, which have washed into the tunnel from homeless camps upstream, are strewn across the floor. Artless scrawls cover the walls. Water pipes and electrical tubing snake across the ceiling. The drain doubles as a utility tunnel.

I hear footsteps, the soft crunching of gravel that gradually gets louder. It's Billy, who lives in this drain with several other men and five cats.

"It's peaceful down here," says Billy, dressed in black jeans and a black "Welcome to Fabulous Las Vegas" jacket. "Besides having a few bad roommates, you couldn't ask for a better place to live. It's cool in the summer. It's warm in the winter."

Hundreds of people live in the Las Vegas storm drains: teens, baby boomers, and senior citizens; poets, artists, and madmen; hustlers, whores, and Vietnam vets. Most of them are addicted to alcohol, drugs, or gambling. Or all three. Some are dying of cancer or AIDS. All of them are in danger of getting washed away during the next flash flood. Despite its aridity—only 4.5 inches of rain a year—Las Vegas has a long and ugly history of flash floods. In 1985, following a series

of summer floods that crippled Las Vegas, the state authorized the creation of the Clark County Regional Flood Control District. The goals of the District included a master plan to reduce flooding. In '88, construction began on the first project: the channeling of the Las Vegas Wash between Craig Road and Civic Center Drive.

The flood-control system now consists of 73 detention basins and 450 miles of channels, about 300 miles of which are underground.

A strange beauty can be found in this system. I sweep the beam of the flashlight over the floor, start upstream and enter a rectangular chamber crowned with a grate. The walls of the chamber are sweeps of tattoo color in this black-and-gray world: blue, green, yellow, orange, purple, pink, and red. Interlocking letters stretch from the floor to the ceiling. Arrows zip and sparkles dance. Anime girls with big eyes, small noses and pixie haircuts crouch in the shadows, as beautiful as angels.

When I discovered this art gallery, a different exhibit was on display. A giant wasp, wings up and stinger down, floated on an off-white plane. "Diagram for Self-Destruction" was scrawled in the background and the wasp's anatomy was labeled in block letters: "Just Know/That We/Must Learn/to Use/Things and/Love People/Not Love/Things and/Use People." Next to the diagram was a portrait of a man with a stone face and Caesar haircut. Its legend read, "Embrace Truth in a World of Lies." Good advice, especially in Las Vegas.

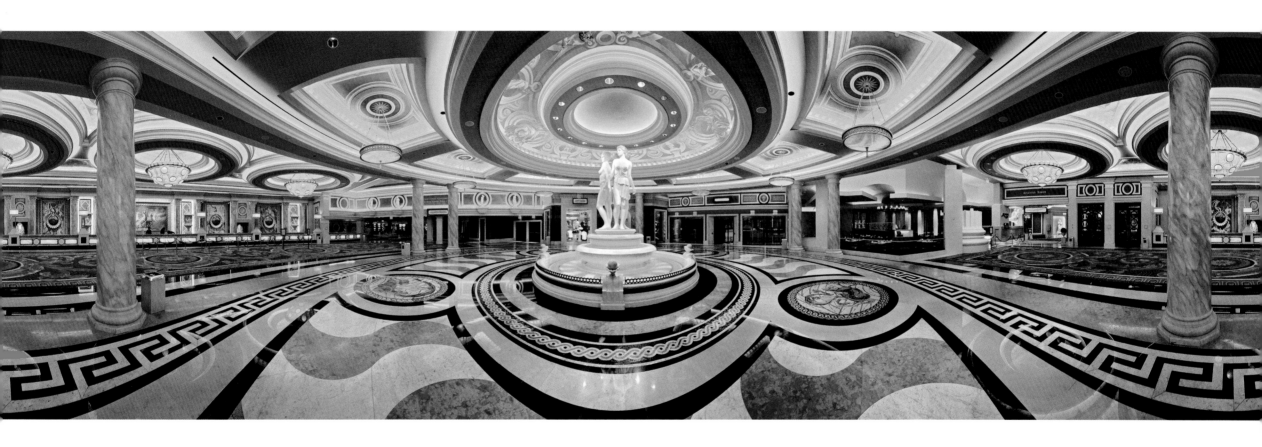

Caesars, Lobby, 2006

Caesars, Forum Shops, 2006

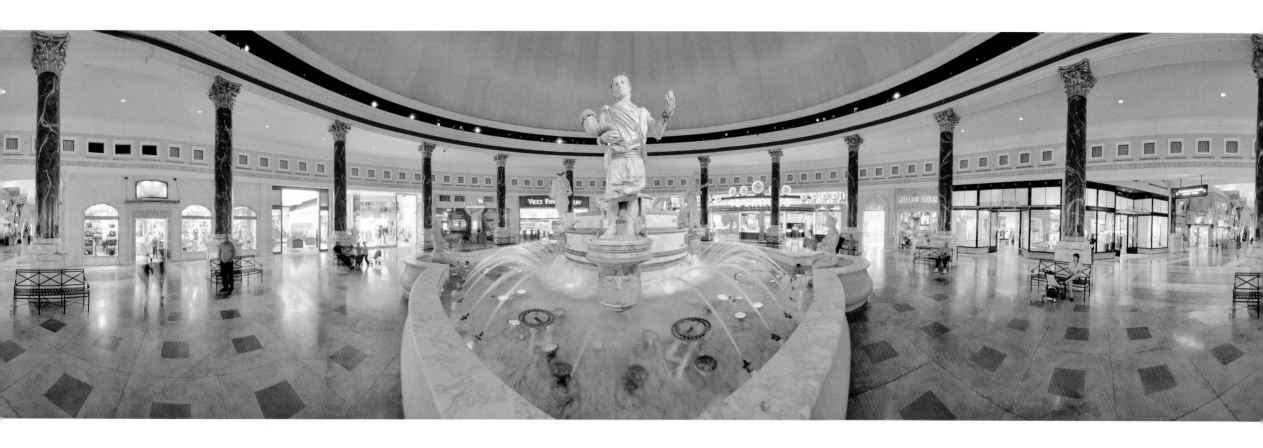

Fremont Street, 2006

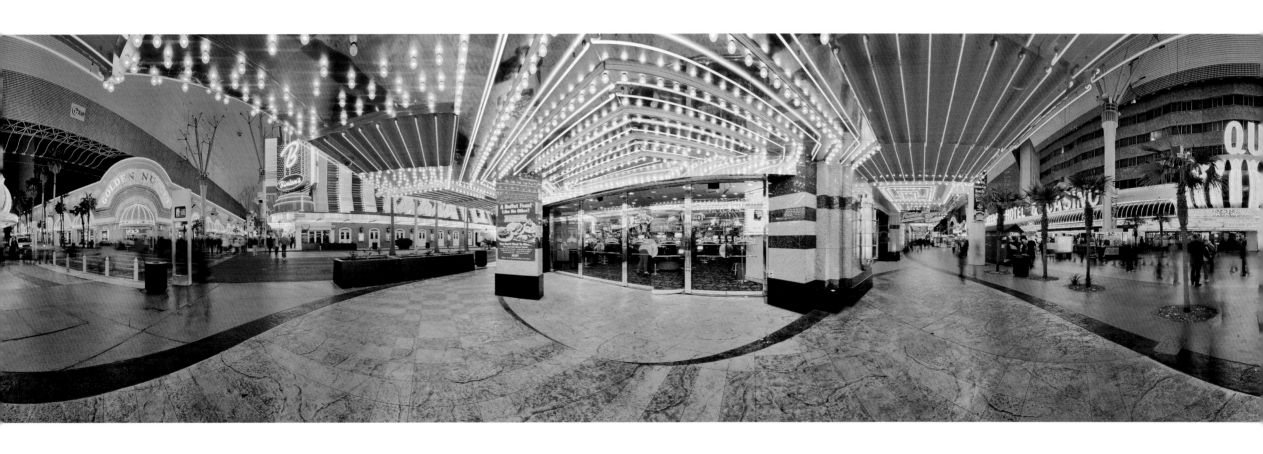

Luxor, Lobby, 2005

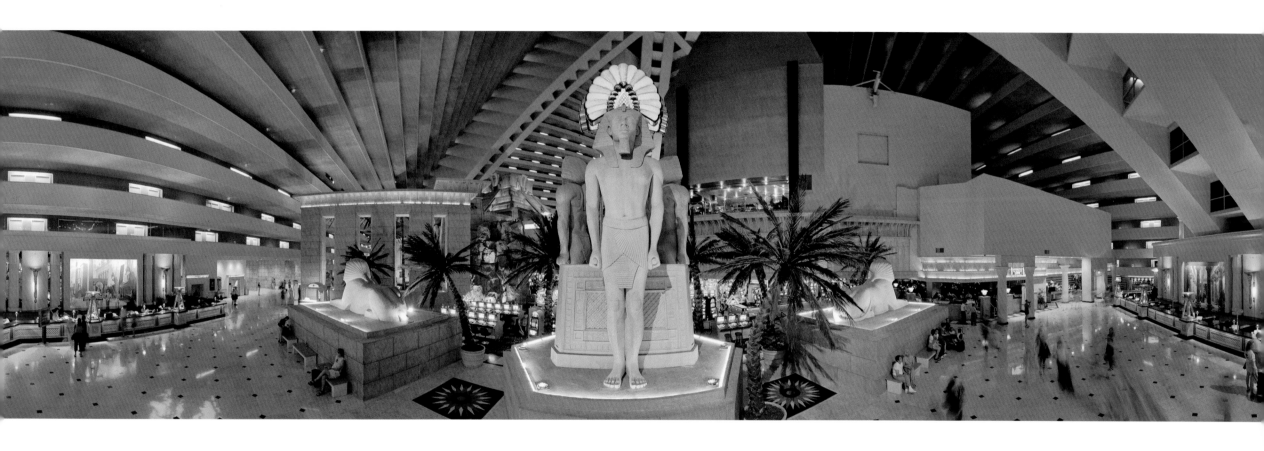

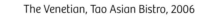
The Venetian, Tao Asian Bistro, 2006

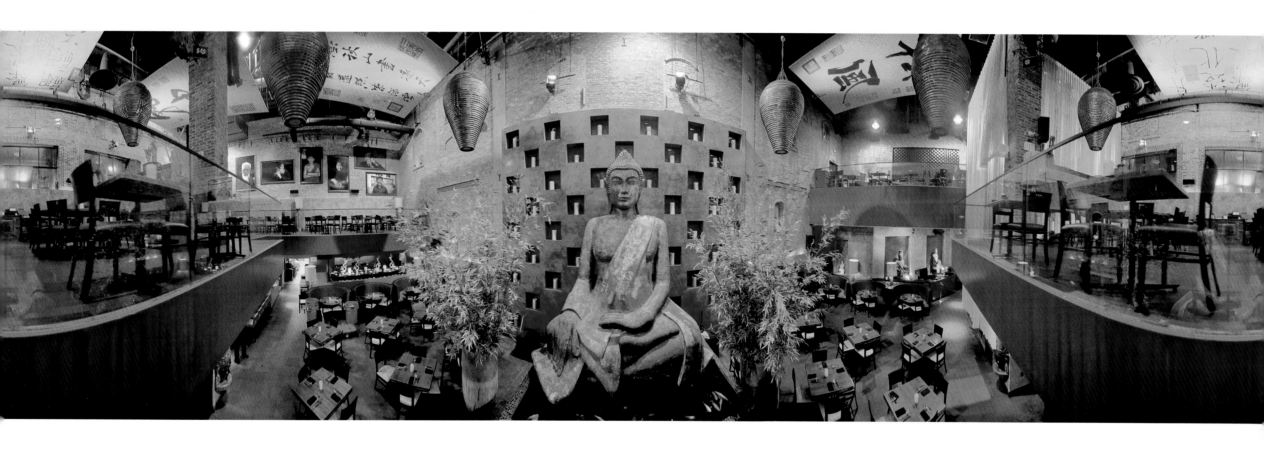

The Venetian, Lobby, 2001

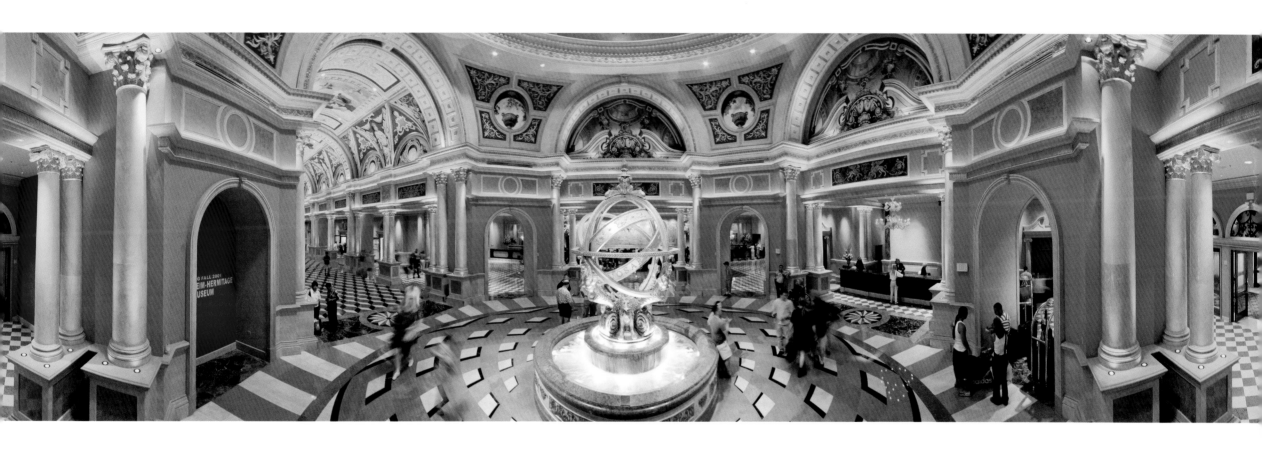

Biographies

THOMAS R. SCHIFF has published three previous collections of panoramic photographs: *Panoramic Cincinnati* (1999), *Panoramic Ohio* (2002), and *Panoramic Parks of Cincinnati* (2005). In 2003, *Panoramic Ohio* accompanied a touring exhibition that opened at the Cincinnati Art Museum.

Schiff has been exploring various photographic formats for forty years. His early photography featured black-and-white images focusing on architectural details, storefront facades, and windows. Schiff turned to panoramic photography in 1994, as a new approach toward exploring illusions, reflections, and multiplicity within his images. He is currently involved in numerous book projects, including his work with the panoramic camera on a survey of American architecture, a series of panoramic photographs of the buildings of Frank Lloyd Wright, and a series featuring the mid-century modernist architecture in Columbus, Indiana.

Schiff is chairman and CEO of John J. & Thomas R. Schiff & Co., Inc., as well as a director of Cincinnati Financial Corporation. He resides in Cincinnati, Ohio.

DAVE HICKEY is a free-lance writer of fiction and cultural criticism. He has written for most major American cultural publications including *Rolling Stone*, *ARTnews*, *Art in America*, *Artforum*, *Interview*, *Harper's Magazine*, *Vanity Fair*, *Nest*, *The New York Times*, and the *Los Angeles Times*. His critical essays on art have been collected in two volumes published by Art Issues Press, *The Invisible Dragon: Four Essays on Beauty* (1993), which is in its sixth printing, and *Air Guitar: Essays on Art & Democracy* (1998), now in its eighth printing. *Stardumb* (Artspace Press, 1999), is a collection of stories with drawings by artist John DeFazio. He has two books in production at the University of Chicago Press: *Connoisseur of Waves: More Essays on Art & Democracy* (2009) and *Feint of Heart: Essays on Individual Artists* (two volumes) (2010), as well as a new edition of *The Invisible Dragon* that will be released in English and German.

Hickey was awarded a *MacArthur Foundation Fellowship* for 2002-2007. In May 2003, he received an honorary degree from The Rhode Island School of Design. In 2007, he received a Peabody Award for his work on Ric Burns' biographical documentary of Andy Warhol for the American Masters series on PBS. Hickey presently holds the position of Schaeffer Professor of Modern Letters at the University of Nevada, Las Vegas.

PHIL HAGEN is a Las Vegas-based journalist, and award-winning editor of *Architecture Las Vegas* and Nevada Public Radio's *Desert Companion*. He was editor of *Las Vegas Life* when it earned the Silver Medal for General Excellence from the National City & Regional Magazine Association (2003). He writes for a number of publications, including *Sunset*, *TimeOut Las Vegas*, and *Sources + Design*, a regional trade magazine.

A.D. HOPKINS is a special projects editor heading a team of investigative and in-depth reporters for the *Las Vegas Review-Journal*. In 1975 he started the first magazine covering the business end of casino gaming, and found much of his material on Fremont Street. He edited *Cerca*, a magazine about outdoor travel in the region surrounding Las Vegas, and with the late K.J. Evans was co-author and editor of *The First 100: Portraits of the Men and Women Who Shaped Las Vegas*.

MATTHEW O'BRIEN is a Las Vegas-based journalist. He's the author most recently of *Beneath the Neon: Life and Death in the Tunnels of Las Vegas*, which chronicles his adventures exploring the city's underground flood channels. He's also a longtime writer for *CityLife*. O'Brien was born in Washington, D.C., and raised in the Atlanta area. He has lived in Las Vegas since 1997.

BENEDETTA PIGNATELLI chose to live and love in Las Vegas. She's a photojournalist who has worked for publications in this country, Germany, Greece, Monaco, France, and her native Italy. Her work has appeared in *Vegas Magazine*, *Las Vegas Weekly*, *Los Angeles Times*, *Vogue Italia*, and *Casa Vogue*. Among the notables she has interviewed are fashion designer and art patron Miuccia Prada, photographer Mary Ellen Mark, the singer Bjork, actress Isabella Rossellini, and culinary giants Alice Waters and Lidia Bastianich. She aspires to learn Portuguese and how to weld with an acetylene torch.

DAVID SURRATT left North Carolina and a career in molecular biology in 2003 for a chance to live, study, and write in Las Vegas. He's just completed work for an MFA in Creative Writing from the University of Nevada, Las Vegas, along with a pile of freelance music, theater, nightlife, and travel reviews for various publications including the *Los Angeles Times*, London-based *Time Out* travel guides, and *Las Vegas CityLife* newspaper, where he's currently a staff writer. Surratt still can't describe this many-headed Vegas animal to his own satisfaction, but keeps trying.

KIM THOMAS, a 30-year resident of Las Vegas, is a novelist and a detective with the Las Vegas Metropolitan Police Department. He joined Las Vegas Metro after several years in the Air Force as an electronic warfare technician, and then in a top-secret civilian position at the Tonopah Test Range in Central Nevada. He's been with Las Vegas Metro for 15 years, and as a detective has worked a number of details, including burglary, larceny, retail/construction theft, and auto theft. He's currently on the forgery detail. Past assignments allowed him to work closely with the FBI, ATF, DEA, and the Secret Service. While working as a detective, Thomas also pursued an MFA degree in Creative Writing from the University of Nevada, Las Vegas. His first novel, *Vegas, One Cop's Journey*, was published in 2005. His second, *Dope Opera*, is due out in 2009.

DOUGLAS UNGER is the author of four novels, including *Leaving the Land* and *Voices from Silence*. His most recent book is *Looking for War and Other Stories*. He is the co-founder of the MFA in Creative Writing International and Schaeffer Fellowship PhD programs at the University of Nevada, Las Vegas, where he is the current chair of the Department of English. He also serves on the boards of Words Without Borders and Point of Contact/Punto de Contacto in support of literary activism around the world. He worked for five years as the Grants and Acquisitions Director of the International Institute of Modern Letters; he is a Guggenheim fellow, and has been a Fulbright lecturer. He travels extensively in support of literary activism around the world.

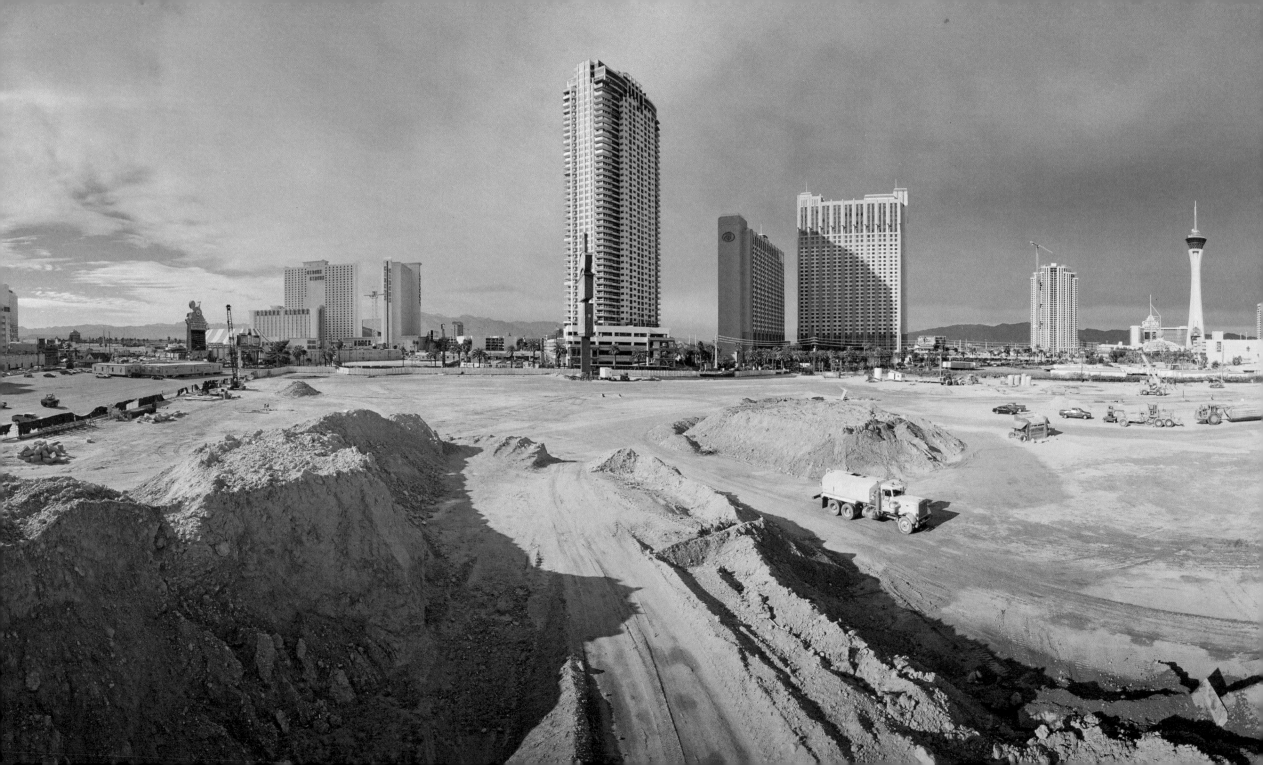